The Campus History Series

AUSTIN COLLEGE

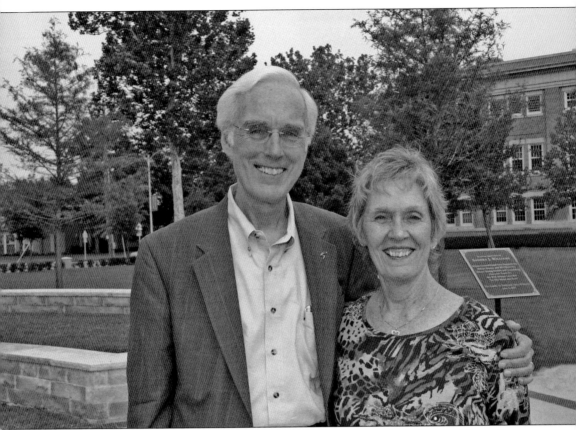

Dr. Oscar C. Page began his duties as president on July 1, 1994, and retired from that post on July 1, 2009. He is pictured here with his wife, Anna Laura Page. The years of his service have witnessed many significant improvements in the life of the college. This was especially so with an increased level of academic excellence, an expanded physical plant, and greater national prestige. This volume marks the presidential transition between his leadership and that of Dr. Marjorie Hass.

ON THE COVER: A crowd of Austin College football fans is assembled at Cashion Field to enjoy a game by the Kangaroos, *c.* 1935.

The Campus History Series

AUSTIN COLLEGE

LIGHT TOWNSEND CUMMINS, EDITOR
JUSTIN BANKS, IMAGE EDITOR

ELIZABETH A. ELLIOTT
DAVID C. LOFTICE
TRANG NGO
JOSHUA POLLOCK
PAIGE RUTHERFORD
VICTORIA SHEPPARD
WILLIAM WEEKS
JACQUELINE M. WELSH

ARCADIA
PUBLISHING

Published by Arcadia Publishing
Charleston SC, Chicago IL, Portsmouth NH, San Francisco CA

Printed in the United States of America

Library of Congress Catalog Card Number: 2009931118

For all general information contact Arcadia Publishing at:
Telephone 843-853-2070
Fax 843-853-0044
E-mail sales@arcadiapublishing.com
For customer service and orders:
Toll-Free 1-888-313-2665

Visit us on the Internet at www.arcadiapublishing.com

This volume is dedicated to Oscar and Anna Laura Page in appreciation for their years of service to Austin College.

CONTENTS

ACKNOWLEDGMENTS

This volume is the result of a collaborative learning project. Eight undergraduate students worked with Light T. Cummins in researching and writing this volume as part of their class activities during a seminar that met in the spring semester of 2009. The history of Austin College was the topic of this class. These eight students wrote the historical narratives and captions contained in this volume. The selections of images seen in the following pages are also the result of collaboration. College Archivist Justin Banks and his students, Ayesha Shafi, Susan Le, Rebeka Medellin, and Gunjan Chitnis participated in this project by choosing the photographs contained in this volume. Light Cummins provided continuity and editing for the project. All those involved in this project extend special thanks to Susan Storan, regional studies secretary, for her hard work and office skills. Additionally, Vickie Kirby, Gayle Bowers, Lawanna Slaughter, Leslie Cummins, Allyse Snyder, Austin Tooley, and Joshua K. Gilbreath also assisted at various stages. Jerry Holbert, Mike Imhoff, and Patrick Duffey encouraged this project and gave it their support. Unless otherwise noted, all images in this volume appear courtesy of the Austin College Archives.

INTRODUCTION

*[La Photographie] répète mécaniquement ce qui ne pourra
jamais plus se répéter existentiellement.*

–Roland Barthes, *La chambre claire*

The pictorial history you hold in your hands was produced by a talented group of students and two Austin College faculty members—Light T. Cummins and Justin Banks. Their collaboration exemplifies a uniqueness of Austin College's academic model: an active, engaged journey of shared learning. The college's faculty members serve as guides and partners in the thrill of discovery and intellectual growth. The close bond between student and professor has launched generations of successful alumni and continues to draw bright individuals to the campus. This volume embodies Austin College's core mission to educate students in the liberal arts and sciences in order to prepare them for rewarding careers and for full, engaged, and meaningful lives.

It is a mission with roots that are deep and strong, preserving the college from its founding in 1849, through periods of profound national and international change. The story of the college told in this volume shows how these values have been carried forward from generation to generation, often in the face of steep odds, toward ultimate success. Those of us who love Austin College owe an incalculable debt to the men and women who shaped this great institution. This book reminds us of the legacy we have inherited from them and inspires us to meet our responsibility to keep the flames of teaching and learning well tended. We must provide a bright future for the generations who will join the Austin College community.

Visual histories are valuable in that they make use of the veracity of the camera to realize the past in the present. However, it takes an act of imagination to make historical photographs speak to us. Black and white images can easily appear only as faint echoes of an unreachable, unknowable past. We must use creative energy to reach into the image and animate the full vitality of the moment preserved. To really see history, we should enliven the faces in the photographs to understand their attendant living passions, cares, and hopes. The contributors to this volume have presented these photographs in ways that help us enter into the world of Austin College's past. The pages that follow tell a remarkable story, and I encourage you to allow yourself to be drawn into the ongoing adventure that is Austin College.

—Marjorie Hass
President
Austin College

One

THE SEARCH FOR

AN IDENTITY

1849 TO 1897

Presbyterian minister Daniel Baker first had the idea of founding a college for young men in Texas during a visit he made to the new republic in 1840. Nine years later, that vision became a reality when Baker and a group of supporters secured a charter from the State of Texas to create Austin College, named for Stephen F. Austin. In 1850, the college opened its doors in Huntsville, where it prospered in the years before the Civil War but fell into decline during and after that conflict. A succession of presidents including Samuel McKinney, Reverend Baker, Rufus Bailey, and Samuel Luckett led the college through its first years in Huntsville. In 1876, President Luckett moved the school to Sherman in the hopes that it might attract a larger number of students and enjoy increased financial support. After searching for a viable identity, Austin College became a military college that required all of its students to belong to a corps of cadets.

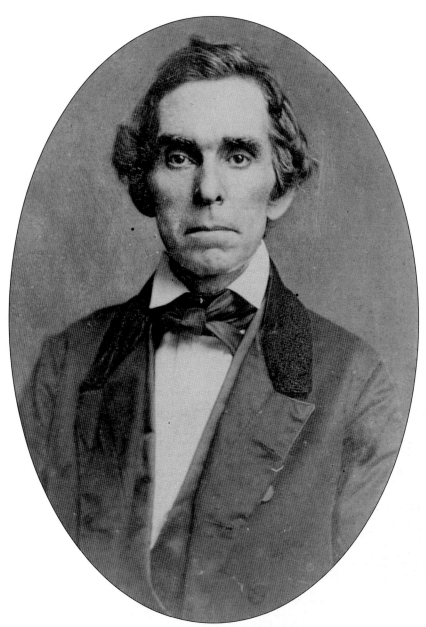

Samuel McKinney served as the first president of Austin College while it was located in Huntsville, Texas. Born in 1807, he attended the University of Pennsylvania. He was ordained as a Presbyterian minister and was headmaster of a girl's school in Mississippi before coming to Texas. Under his leadership, the student body quickly grew after classes began in 1850. He specified a course study that required familiarity with Latin, Greek, and literature. In order to graduate, each student was required to go before the board of trustees and demonstrate his knowledge through a public examination. These spring examinations became important social events for the college, leading directly to its commencement activities. President McKinney also oversaw the construction of the college's first building in 1851. Samuel McKinney served two nonconsecutive terms as president of Austin College, the first from 1850 to 1853, and the second from 1862 to 1871.

The Old Prospect Church in Washington County was the birthplace of Austin College, which came to life when a group of Presbyterians assembled to found the school. Led by Daniel Baker, they wrote a proposed charter. On October 13, 1849, the governor of Texas signed the charter and legally created the college, which began classes the following year.

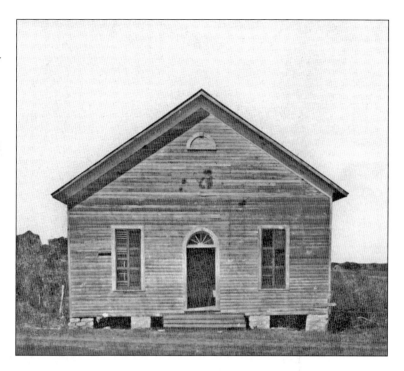

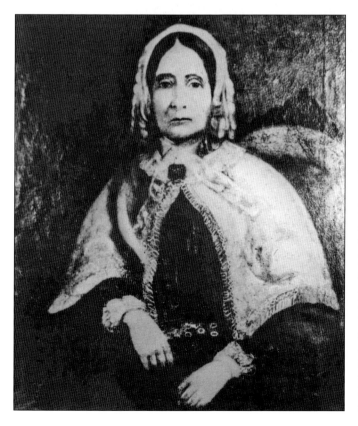

Emily Austin Bryan Perry was the sister of Stephen F. Austin. She and her husband met with Daniel Baker, who was attempting to establish a college in Texas. The Perrys gave Reverend Baker 1,500 acres of land as the first donation to the college. Baker would later insist that the school be named in honor of Stephen F. Austin because of this donation. (Image courtesy of the Brazoria County Historical Museum, Angleton, Texas.)

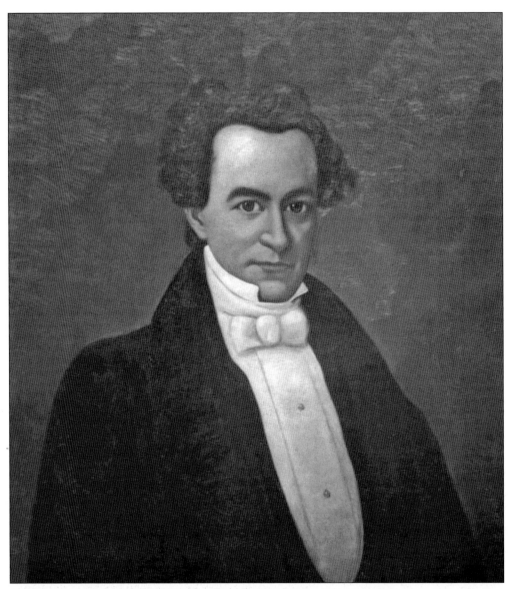

Stephen F. Austin, whose name the college memorializes, is popularly known as the "Father of Texas" because he brought the first Anglo American settlers into Mexican Texas, fulfilling settlement plans first envisioned by his late father, Moses Austin. A bachelor, Stephen made his home at Peach Point Plantation with his sister Emily and her family. In the mid-1830s, he advocated the separation of Texas from Mexico and helped motivate the revolt in Anglo American sections of the province. During the Texas Revolution, he went to the United States to secure assistance for the Anglo Texans. In 1836, he became secretary of state for the Republic of Texas but died of natural causes at the end of that year. He was particularly passionate about education and advanced the first attempts to found schools in Texas, although he did not live to see the fruition of these plans.

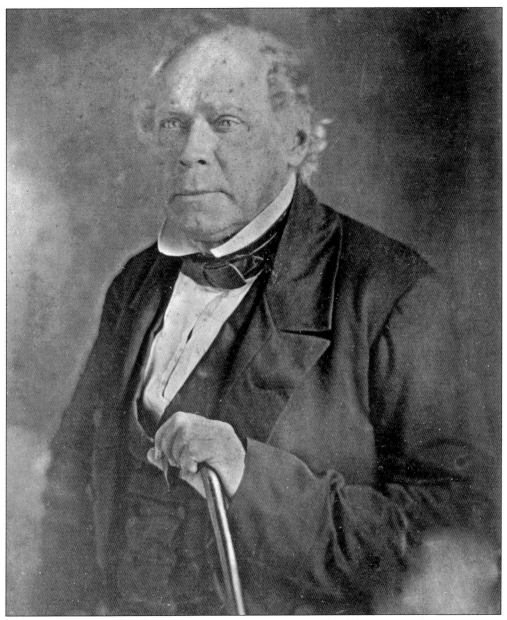

Daniel Baker founded Austin College in 1849, served as its second president, and was its financial agent. Born on August 17, 1791, in Midway, Georgia, and orphaned by the age of eight, he turned to religion as his path through life. He became an ordained Presbyterian minister in 1818. Baker first arrived in Texas in 1840 and decided to found a college to educate Presbyterian young men. Baker personally selected the institution's first president, Samuel McKinney, and its board of trustees. He raised the funds necessary to acquire supplies for the newly formed institution as well as money to hire instructors. In 1853, Baker became president of Austin College while still remaining its financial agent. During his tenure, the college began offering its first bachelor of arts degrees and introduced athletics. Fund-raising was his foremost priority, and he spent a great deal of his presidency traveling the country soliciting financial support.

The front porch of Peach Point Plantation, near present-day Freeport, Texas, marks the location where Daniel Baker outlined his plans for a college to Emily and James F. Perry. Today, Emily Austin Bryan Perry is remembered with a plaque on the Austin College Honors Court for being the first benefactor of the college. (Image courtesy of the Brazoria County Historical Museum, Angleton, Texas.)

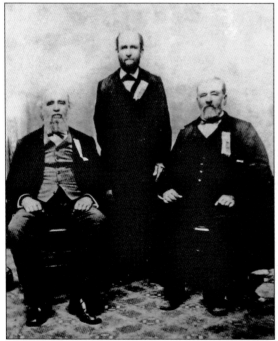

Pictured from left to right, Moses Austin Bryan, Guy Morrison Bryan, and William Joel Bryan were three sons of Emily Austin Bryan Perry. Guy M. Bryan served on the college's board of trustees and donated the stained-glass window of Stephen F. Austin, which is located in the lobby of the Caruth Administration Building. (Image courtesy of the Brazoria County Historical Museum, Angleton, Texas.)

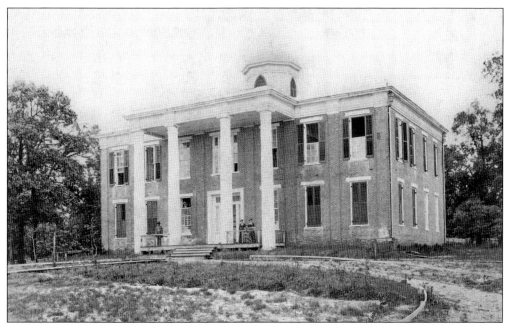

The original Austin College building in Huntsville first hosted classes in October 1852. The building was divided so that each floor had two large rooms for group functions and four smaller rooms for classes. It still stands today as a historical landmark on the campus of Sam Houston State University, which later took over the original Austin College campus.

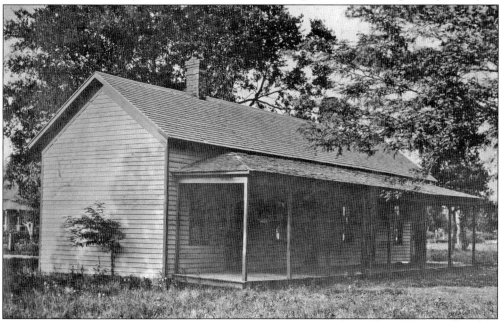

For several years after classes began in Huntsville, the local citizens of Huntsville boarded students in their homes. Later, students began living in college boardinghouses like the one pictured. Students were expected to maintain proper deportment both on and off the campus. They signed a pledge vowing to uphold all the rules and regulations set forth by the college.

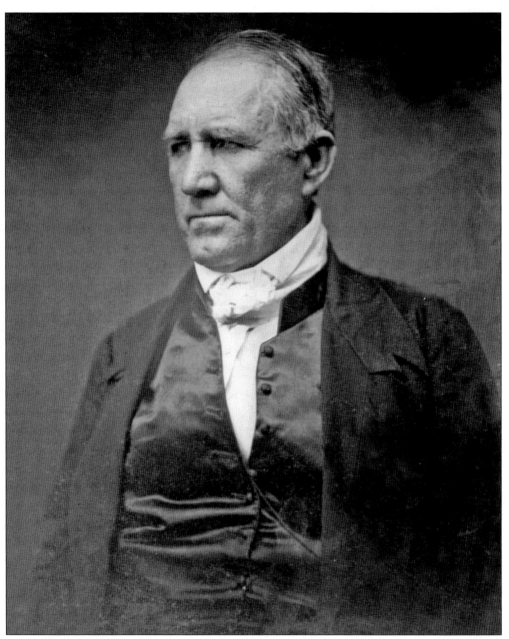

Sam Houston served as chair of the Austin College board of trustees during the early 1850s. Two of his sons attended the college during the years when it was located in Huntsville. Early in that decade, Houston lived in Huntsville, where he practiced law and served as a U.S. senator. At the time of secession, he was the governor of Texas. Refusing to become a Confederate supporter, he left office and returned to Huntsville, where he died in 1863. At the time of his passing, he was living in an unusual home known locally as the "Steamboat House" because it resembled one. The Steamboat House was built by Austin College president Rufus W. Bailey. Former college president Samuel McKinney stood at Houston's bedside during his final illness. Houston's last words were spoken to McKinney moments before his passing.

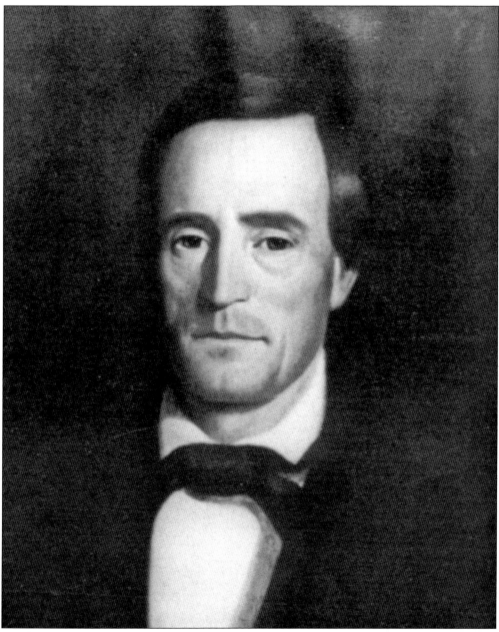

Henderson Yoakum was a Huntsville attorney who served on the first Austin College board of trustees. A law partner of Sam Houston, he supported Daniel Baker's attempts to found Austin College and was instrumental in having the school choose Huntsville as its home. In 1856, he established the law department at Austin College and was one of its first professors. Early boards of trustees included other prominent Texans, including Stephen F. Austin's nephew Guy M. Bryan; Hugh Wilson, who was known as the "Father of Texas Presbyterianism"; Dr. Anson Jones, the last president of the Republic of Texas; and Abner Lipscomb, chief justice of the Texas Supreme Court. Noted Texas architect Abner H. Cook, who designed the Governor's Mansion in Austin, also served as an early trustee along with pioneer Texas journalist Edward Hopkins Cushing and Judge James A. Baker.

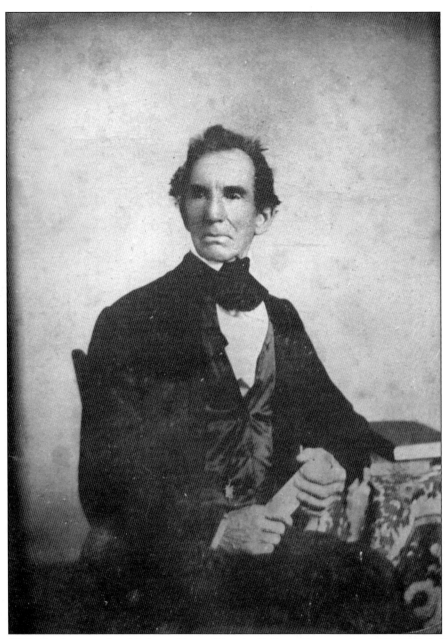

Rufus W. Bailey became the third president of Austin College. Born on April 13, 1793, in North Yarmouth, Massachusetts, he graduated from Dartmouth College in 1813 and eventually became the president of the Staunton Female Institute in Virginia. After assuming the Austin College presidency, he went so far as to pay $700 to its creditors from his own pocket in order to keep the school open. He thereafter successfully raised the funds needed to retire the college's debt. Bailey's efforts, however, would be for naught because of the Civil War. In 1861, Bailey recommended the school cancel collegiate instruction, although secondary-level classes continued for the duration. Chartered before 1861, Austin College was the only Texas college to reopen and operate under their original charter after the Civil War. This accomplishment was in large part due to the leadership of Rufus Bailey.

Samuel Magoffin Luckett became president of Austin College in January 1871. Born in Logon County, Kentucky, he earned a bachelor of arts degree from Centre College in 1859 and graduated from the Danville Theology Seminary in 1866. Luckett devoted his time to recruiting prospective students and improving the college's finances. In 1874, President Luckett made the momentous decision to move Austin College from Huntsville to Sherman, which seemed a more promising location. He superintended the move but resigned the presidency in 1876, to return to preaching. He returned as president in 1887 to preside over a more stable college that enjoyed a new main building, an accomplished faculty, and a larger student body. In 1889, he converted Austin College into a military school with over 60 students in the cadet corps. Campus life also improved with the creation of a YMCA chapter, the arrival of fraternities, and the beginning of intercollegiate athletics.

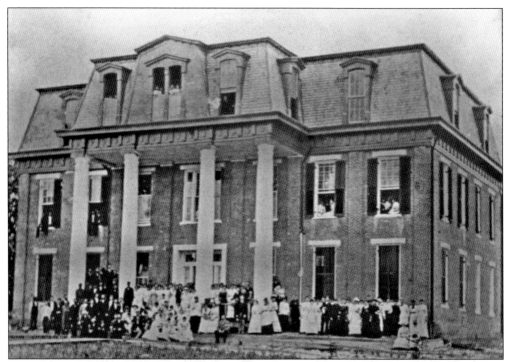

When Austin College moved to Sherman, Governor Oran M. Roberts and the State of Texas created the Sam Houston State Normal School in Huntsville. The normal school bought the Austin College campus and occupied the remodeled original building as seen above. C. P. Estill, an Austin College professor, decided to stay as the first faculty member of the school, which today is Sam Houston State University.

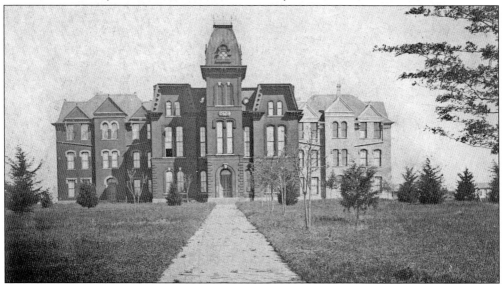

The original main building in Sherman was formally dedicated on September 2, 1878. As one visitor noted, "It was pleasant to see that stately and handsome building rising within a large and dear campus." For almost 15 years, this large structure housed the entire college including offices, meeting rooms, classrooms, and the chapel.

Edward P. Palmer assumed the role of Austin College president in the fall of 1882. Born in 1826, he spent his early life in Summerville, South Carolina, attended the University of Georgia, and graduated from the Presbyterian Theological Seminary. Ordained in 1849, Palmer served as a Presbyterian pastor, working in many churches across the Gulf Coast area of the South. He then joined the faculty of Louisiana State University, where he earned a doctorate of divinity in 1874. Despite his best efforts, the college continued to operate during his presidency with a heavy debt that threatened its very existence. By the fall of 1884, the atmosphere at Austin College was bleak. Unsure of how to address the financial crisis, Palmer made the decision to resign as president on November 3, 1884, after only two years in office. The college was surviving, but only barely.

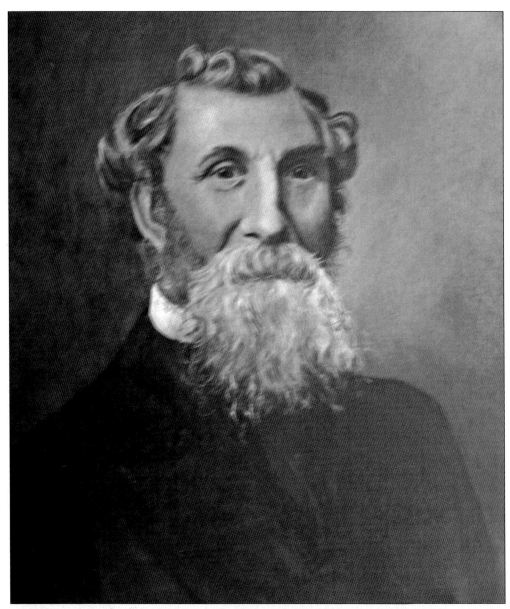

Donald MacGregor, a Scottish-born businessman, replaced Edward Palmer. After serving in the 42nd Regiment of Scottish Highlanders, MacGregor came to the United States and settled at Houston. He became actively involved in the Presbyterian Church and chose to study for the ministry. After his ordination in 1875, MacGregor served as the pastor of the Chapel Hill Presbyterian Church and the Second Presbyterian Church of Houston. In 1885, MacGregor formally took over as president, but he remained in Houston. For the 1885–1886 school year, instructor J. C. Edmonds supervised the day-to-day operations of the college and boarded all the young men in attendance. After a thorough assessment of the school's financial state, MacGregor made it his priority to quickly and efficiently liquidate the school's debt. He sought out former business associates and friends, in particular J. N. Chadwick, who was a wealthy landowner in southern Texas with a deep admiration for MacGregor and Austin College. Chadwick donated $1,000 along with a 1,232-acre farm in Austin County.

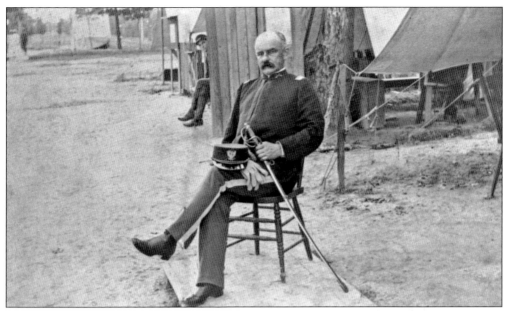

J. C. Edmonds, who ran the college in the mid-1880s, kept the college functioning; his background in mathematics was an asset to the curriculum. While a Confederate soldier fighting at the Battle of Cold Harbor, a bullet struck him in the chest, but a Bible in his shirt pocket lessened the impact and saved his life. Edmonds insisted that all Austin College students carry a Bible.

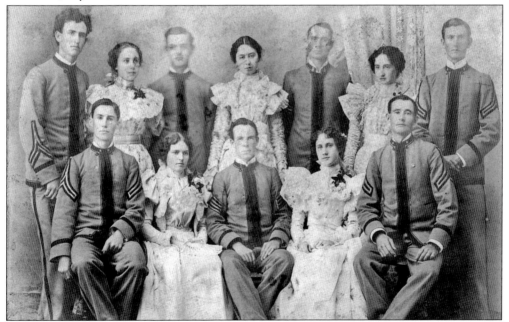

Austin College experienced growth when it became a military college in 1889. From the students' viewpoint, it also enhanced college life. The cadets shared social events with the local women's colleges in Sherman. The cadet companies were allowed to choose sweethearts to serve as maids of honor or mascots. Pictured here are Company B officers with their maids of honor in 1897.

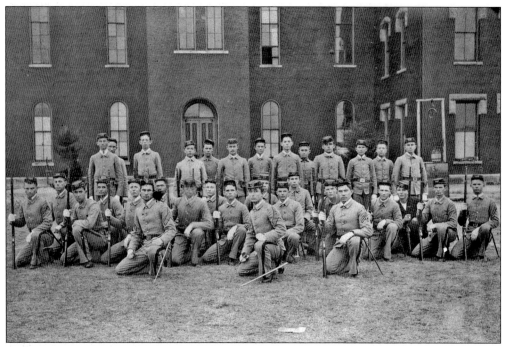

The military program at Austin College was registered with the U.S. War Department as an official military training detachment. Its aim was to enforce discipline with the use of a regimented schedule. All students were required to attend daily chapel services. The strict program sought to improve the students' character and create well-rounded individuals. The military program was subordinate to the academic program.

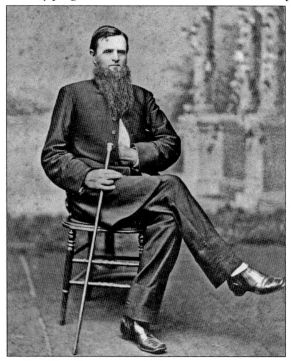

Henry B. Boude was Austin College's president from 1878 to 1881. He received his bachelor's degree from Centre College and also graduated from the Danville Theological Seminary. Fund-raising for the completion of the college building in Sherman fell squarely on his shoulders. He borrowed heavily to pay college-operating expenses. Lacking the necessary funds to pay the loans he had negotiated, President Boude decided to resign in September 1881.

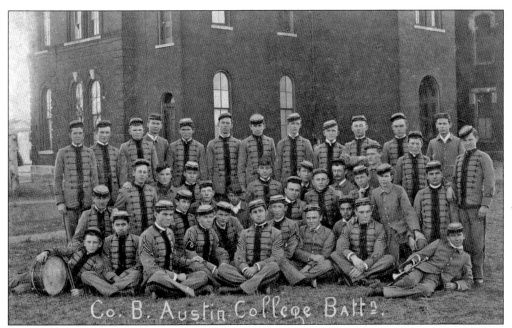

Co. B. Austin College Batt?.

During the military era, each cadet was expected to wear his uniform at all times. In the fall of 1889, the corps was divided into A and B companies, with the students in the collegiate division serving as the officers. Competition between the companies provided a high level of school spirit and camaraderie. Pictured here is Company B in an informal 1889 pose behind the main building.

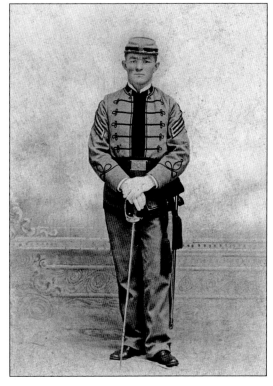

This photograph of Austin College cadet B. I. Dickey of Company A was taken in 1895 and exemplifies a student officer of the time, since only student officers were issued swords. Students were expected to keep their uniforms clean at all times. They stood regular inspection for polished brass, shined shoes, and pressed uniforms. Students had to receive special permission to wear civilian clothes while in Sherman.

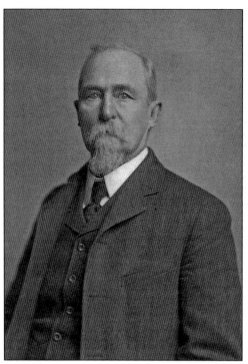

Peter Fullinwider was one of the founders of the Presbyterian Church in Texas and supported the college for many years. His son Peter Fullinwider Jr., an 1860 graduate of Austin College pictured here, served as a trustee in the late 1800s. Students from many subsequent generations of the Fullinwider family have attended Austin College.

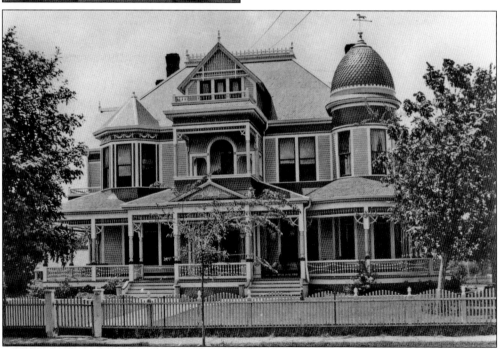

Built in 1895, this grand Victorian residence was the Sherman home of Capt. J. M. Thompson. He made a fortune in the east Texas lumber industry. He constructed this home as a residence for his four sons while they attended Austin College. In 1943, a family member donated the house to the college. It served various purposes until 2000 when, renovated, it became offices and classrooms for the education department.

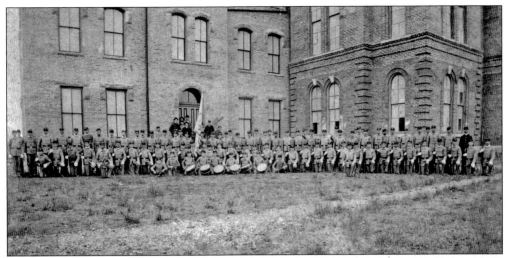

The entire student body of 1890–1891 poses for a formal picture outside of the old main building while dressed in their full uniforms. At the beginning of the 1890s, the college was experiencing a time of marked growth. The endowment had increased to over $20,000, a sum whose interest provided a new source of revenue for the college. Much of this money was earmarked for a full renovation of the main college building.

The roster shown here is of the commissioned and noncommissioned cadet officers from November 1892. J. C. Edmonds was the school's first commandant of the corps. He insured high quality military training would occur on a regular basis. Both of the cadet companies practiced close order drill for 45 minutes each day, and military science courses were included as part of the college's academic program.

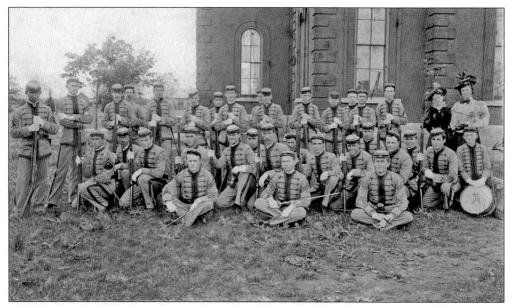

In 1890, the campus received a regular army officer as military commandant, Lt. Karl Coops, a native of Germany who had immigrated to the United States and joined the army. In spite of the popularity of the corps with students, the faculty desired to emphasize academics over military training. Hence, in 1897, the board of trustees eliminated the military program, and the students returned to a civilian existence.

Allison Thompson was hired by President Luckett as a professor of Latin and classical literature. Unable to complete his doctorate of philosophy at the University of Syracuse, Thompson received the only degree of this type ever granted by Austin College in 1894. During his time on campus from 1888 to 1900, Thompson was influential in his involvement with the Nestorian Literary Society, the College Quartette, and the academic administration of the college.

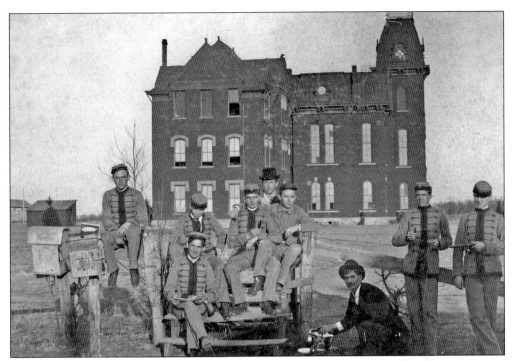

In the 1890s, the Austin College campus was not an appealing place. There was no grass planted, no landscaping, few trees, and dirt ground graced the areas between the buildings. A sagging barbed wire fence surrounded the entire campus. People entering the campus stepped over the fence by means of "step-stiles" that arched over the barbed wire. The students in the photograph are sitting on one of the step-stiles.

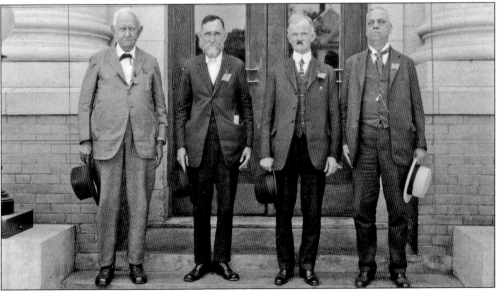

The men in this photograph were all graduates of the college during the time it was located in Huntsville, returning during World War I for a reunion. The man on the far left is Andrew T. McKinney, the son of the first president of the college. He served in the Texas Legislature and was also a member of the original board of regents of the University of Texas.

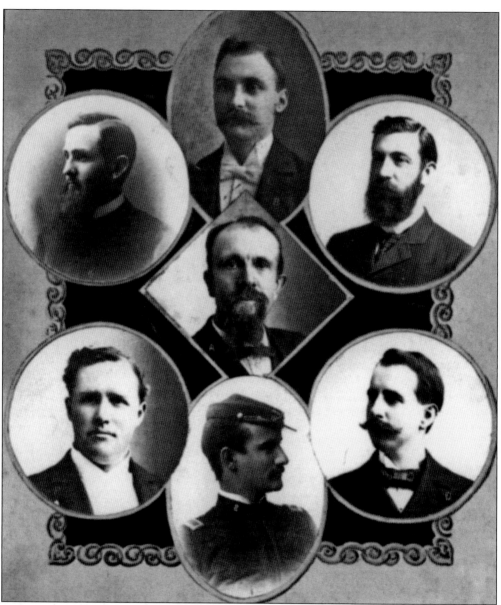

The 1897 faculty of the college was the last that witnessed the school as a military institution. That year, Samuel Luckett (seen in the center) decided that the college should adopt a classical, liberal arts curriculum starting the following academic year. Lt. Karl Koops (seen bottom center) was commandant of cadets. The dismantling of the Corps of Cadets began a new era for Austin College. President Luckett, however, would not remain to oversee the coming of a liberal arts curriculum to the college. He once again decided to leave the presidency. However, he and his wife donated funds to the construction of a dormitory that would eventually bear their names. Luckett also gave his name to one of the neighborhood streets along the present-day north side of campus; the house he lived in still stands on Grand Avenue, although it was moved to its current location in a later era of the college's history.

Two
A COLLEGE FOR
YOUNG MEN
1898 TO 1917

In the early 1890s, Austin College began to attract a professional faculty that offered a liberal arts curriculum concentrating on a classical education. The military program ended in the fall semester of 1897. President Luckett attempted to increase financial support for the school with varying degrees of success. Just before the dawn of the 20th century, Thornton Sampson moved the college in the direction of becoming a civilian college for men. The arrival of Thomas Stone Clyce as president in 1900 accelerated the classical curriculum while the all-male student body began to develop a broad-based social life on campus.

Thornton Rogers Sampson assumed the presidency in June 1897. He was known for his calm demeanor, physical prowess, and love of the outdoors. He spent 14 years in Greece as a missionary, returning in the mid-1890s to the United States, where he served as president of Fredericksburg College in North Carolina before arriving in Sherman. As president, he faced several obstacles including debt, declining enrollment, and general campus unhappiness stemming from the controversial ending of the military program the previous year. To pay off the school's debt, Dr. Sampson borrowed money from the school's endowment. To bolster support among the students after the disbanding of the popular cadet corps, Dr. Sampson encouraged participation in athletics and intramural sports; he hired the school's first full-time coach, Richard Watts, and modernized the school's gymnasium. Dr. Sampson resigned in the spring of 1899 to become the president of the Austin Presbyterian Theological Seminary in Austin, Texas.

Joining the faculty in 1890, Llewellyn J. Mitchell earned his bachelor's and master's degrees from Westminster College. Although his academic specialty was in the field of mathematics, Mitchell also taught the natural sciences. He actively supported the establishment of fraternities. Professor Mitchell became the first academic dean of Austin College in 1916 and served in that position until 1924.

Austin College supported literary societies as an important part of its educational program in the 1800s. These societies grew out of the antebellum institution of the lyceums, public organizations where educated people gathered to discuss books, hear guest speakers, exchange ideas, and engage in rhetorical activities. The Clay Union, whose 1856 program booklet is pictured, was the first literary society founded at the college. It would continue as a college group until the early 20th century.

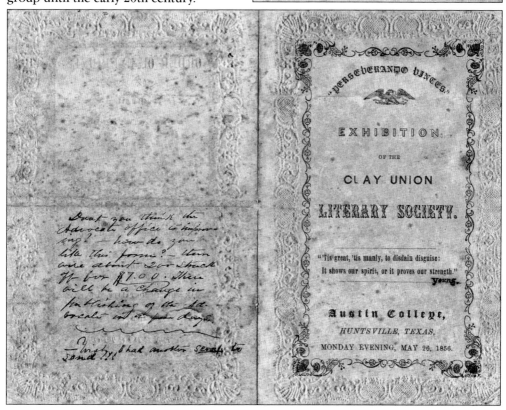

A baseball team organized in the fall of 1892 and became the school's first intercollegiate sport; football followed in 1896. These teams played at the Luckett Field Athletic Park, pictured here. Taken from the corner of modern-day Grand Avenue and Lewis Street, the view looks west toward the railroad tracks. The bleachers are seen in the left center of the image.

A chapter of the Young Men's Christian Association appeared on campus after the Civil War. During the early years of the 1900s, the students decided to construct a campus building for the Austin College chapter. Students helped raise the funds and donated all construction labor. For that reason, it took several years for the building to be completed; it slowly rose west of Luckett Hall, as seen here.

Prior to 1908, most Austin College students lived in private rooming houses. Some faculty members also boarded students in their neighborhood homes. By the late 1890s, the school had constructed several four-room boardinghouses on the northern edge of campus. Students considered these college-owned houses to be crowded, unsightly, and uncomfortable. A group of students living in one of the boardinghouses poses here in their nightshirts.

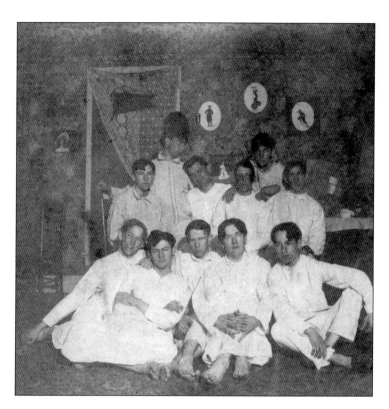

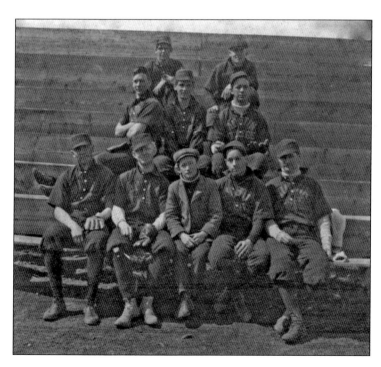

Before they were Kangaroos, the baseball team took the name "Transcontinentals" because the Texas and Pacific Railroad (nicknamed the Transcontinental Line) ran near the campus. Several successful players joined the major leagues, including Chicago White Sox pitcher Charlie Robertson, who pitched a perfect game against the Detroit Lions in 1922.

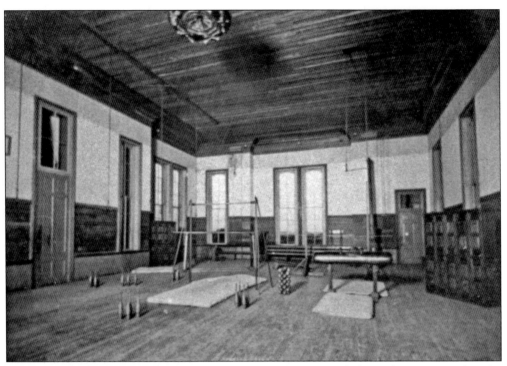

Thornton Sampson was a great advocate of exercise. He once rode from Sherman to Colorado, for his summer vacation, entirely on horseback. He built this original gymnasium in a frame building at the edge of the campus. While modest in size and equipment, it served Austin College students well until the YMCA building was opened in 1911. The new YMCA had a gymnasium and indoor swimming pool located in the basement.

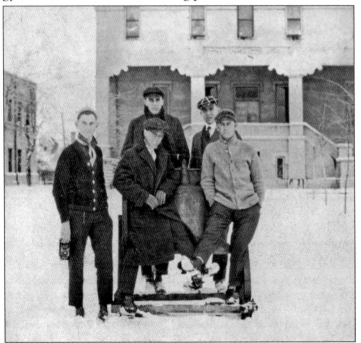

Students pose in the snow in front of the YMCA. Since Sherman sits geographically at the southern end of the Great Plains, it periodically experiences snowfalls that are unknown in warmer parts of Texas and the Southwest. Snow days have thus always constituted special events; to this day, students frolic in the unaccustomed weather and take pictures of the snow.

Starting in the early 1900s, the college began to attract significant support from prominent people in the north Texas area. This was certainly the case for the Heard and Craig families of McKinney. Bessie Heard, seen as a young woman in this photograph, became a generous supporter and gave to the school throughout her lifetime. Her relatives Kathryn Heard Craig and T. E. Craig also became important benefactors.

Student life at the start of the 20th century revolved around the boardinghouses near campus. John Hardy, the college clerk, and his wife operated Hardy House, seen in the top left. Eagleton House, top right, was later the successive residence of faculty members Davis Eagleton and George Landolt. It stood until the 1980s when it was demolished to build the Abell Library.

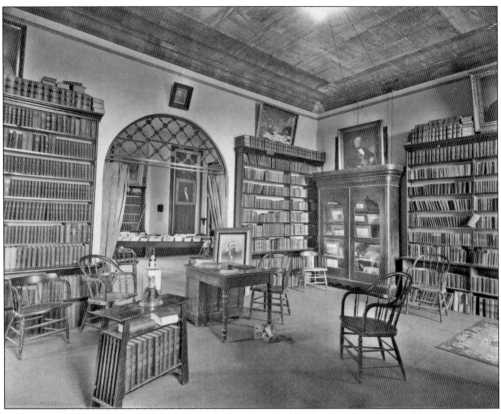

In 1889, due to efforts by Davis Foute Eagleton, the college designated a room in the old main building as a library. The library later expanded into a newly furnished reading room named Chadwick Memorial Hall (as seen in this photograph). After the main building burned, the library moved to Sherman Hall until the construction of the Arthur Hopkins Library in 1960, followed by the Abell Library in 1986.

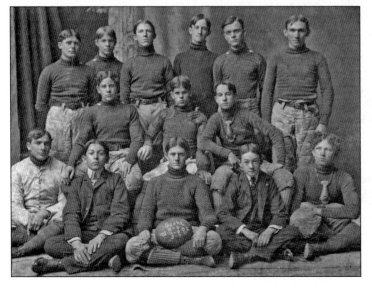

Intercollegiate football began at Austin College in the fall of 1896 with a game against Texas A&M. Students initially operated the team by themselves and one of them served as the player-coach. President Sampson hired a full-time coach in 1898. Pictured here is the 1901–1902 team, with the season's scores written on the football, an antiquated type of ball from before standardization of the sport.

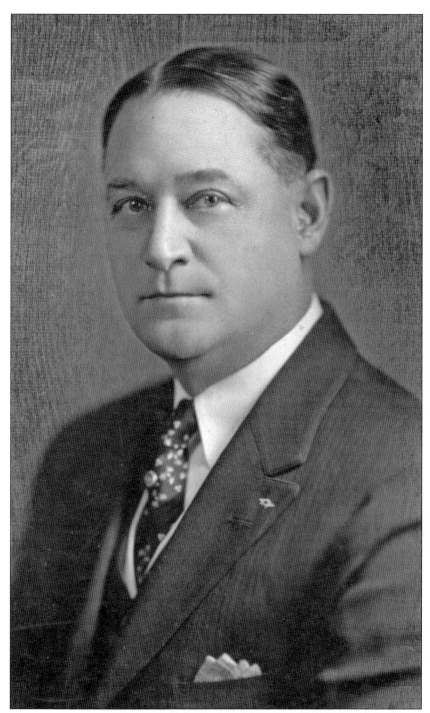

William D. Vinson was a professor of mathematics in the late 19th century. His sons attended the college and became prominent alumni. Attorney William A. Vinson (shown in this photograph) served as a trustee and founded Vinson and Elkins, which today is a preeminent Texas law firm. His brother Robert Vinson was president of the University of Texas. A third brother, John Walker Vinson, became a Presbyterian missionary in China.

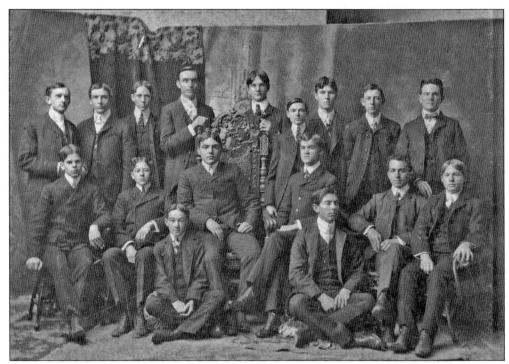

The students in this 1902 picture are members of Clay Union Literary Society. From its days in Huntsville, Austin College had a long tradition of sponsoring literary societies to augment its academic program and to provide social opportunities for students. The literary societies featured campus speakers, engaged in formal debate competitions with each other, and organized public recitations for their members.

The literary societies flourished at Austin College. Until the early 20th century, the college required all students to belong to them and participate in their activities. The two largest societies, the Athenaeum and the Philennonians, had assembly rooms in the main building, as pictured here.

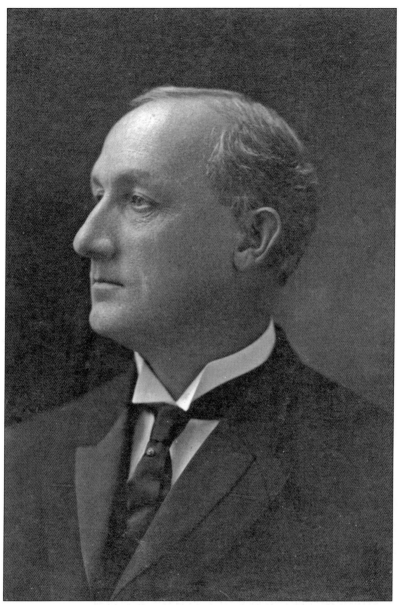

Thomas Stone Clyce became president of Austin College in 1900 and remained in that post until 1931, continuing thereafter on the faculty until his death in 1946. He graduated from Kings College in Bristol, Tennessee, in 1887. In 1893, he married Mayde Perrin, who would also have an impact on Austin College. The Clyces arrived in Sherman on June 10, 1900. They immediately opened their home to students and became popular with them. Since relatively slow railroad travel of that era made it impossible for some students to return home for holidays, it became a campus tradition for many of them to enjoy a Thanksgiving meal at the Clyce home. Some had Christmas dinners there as well; the Clyces hosted a steady round of regular receptions and entertainment for all students. Dr. Clyce's presidency would witness World War I, the college becoming coeducational, the creation of a liberal arts curriculum, the exuberance of the 1920s, a revitalized student life, and the beginnings of the Great Depression.

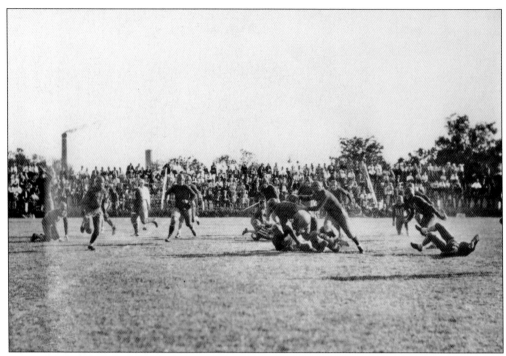

In the early 1900s, the football team became popularly known as the Kangaroos. One legend holds that the Austin College players earned this nickname in 1904 from the opposing coach of the Texas A&M team who marveled at his opponent's ability to hide the ball, perhaps in a kangaroo-like pouch. It also may be that the name came from the college's popular student organization known as the Kangaroo Kourt.

When Thomas Clyce became Austin College's president, a renewed academic rigor took hold across the campus. This obviously posed publicity photograph illustrates Dr. Clyce's firm commitment to academic endeavor. Clyce insisted on scholarly achievement and revamped the curriculum to reflect the rise of disciplinary-based education. He hired additional faculty members in both the humanities and in the emerging social sciences.

This is the staff of the *Reveille* from about 1904. First published in 1891, it was a monthly journal written and edited by the students. It reported campus events and examined issues of interest to the students. The *Reveille* declined as a campus publication and fell by the wayside in 1908 as students began to focus more on producing the Austin College yearbook, the *Chromascope*.

Pictured is the staff of the *Chromascope* from the early 1900s. Begun in 1899, the *Chromascope* has documented college life for over a century, except on two occasions. In the early 1970s, countercultural editors omitted student and faculty names in their volume and only included photographs, rendering it useless today as documentary. Then, in 1986, the college scrapped the *Chromascope* entirely as a money-saving strategy. Student complaints brought it back.

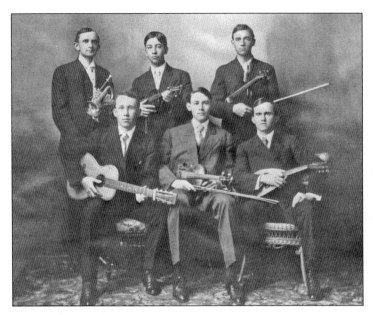

Austin College students formed an orchestra soon after the Clyces arrived in Sherman. A number of student orchestras have performed on campus throughout the years. This includes a group led by Smith Ballew, who went to Hollywood in the early 1920s. He recorded with Columbia Records and regularly performed on the radio. Ballew became a popular singing cowboy at 20th Century Fox in the 1930s and starred in musical Westerns.

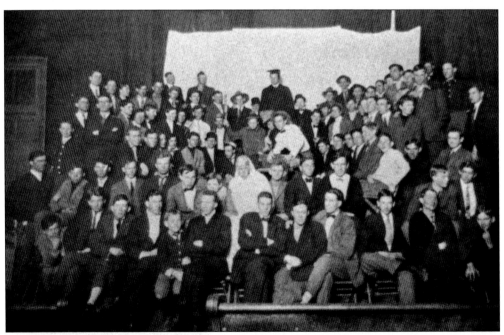

Posing for a group photograph, these students attending a meeting of the Kangaroo Kourt were members of an organization that existed as a semi-secret society on campus. Initiating freshman into the college was one of the Kangaroo Kourt's primary purposes. Corporal punishment was its stock-in-trade. By the second decade of Dr. Clyce's presidency, college officials had decided that the Kangaroo Kourt should be disbanded because of its inherent hazing.

In the fall of 1915, two new student organizations were introduced to replace the Kangaroo Kourt and its paddling of freshmen. The first new group was a social organization called the Kangaroos and the other a student court to handle student infractions judged by peers. Although the Kangaroo Kourt's existence as an overt organization ended officially, it continued to operate as an unsanctioned, secret group until World War II.

President Clyce made Latin and Greek mandatory courses for all the students. He hired W. W. Bondurant to establish instruction in these languages. Bondurant, a graduate of Hampden-Sydney College, eventually became headmaster of the San Antonio Academy and the Texas Military Institute, two private schools in San Antonio, Texas. Professor Bondurant, a Presbyterian, established enduring links between these two schools and Austin College.

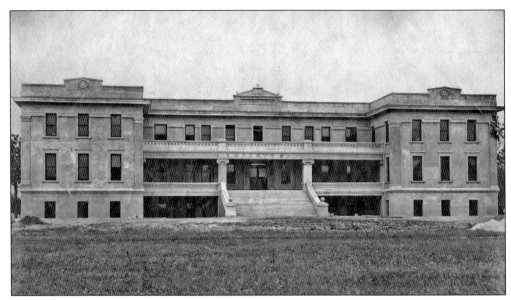

Completed in 1908, Luckett Hall served as the college's first residence hall. The new building enjoyed modern luxuries such as electric lighting, vacuum-generated steam heat, and indoor plumbing. It contained the college dining hall and infirmary. Luckett Hall was demolished in 2004 due to extensive black mold damage deemed too expensive to remove. It stood on the southwest corner of Richards Street and Grand Avenue.

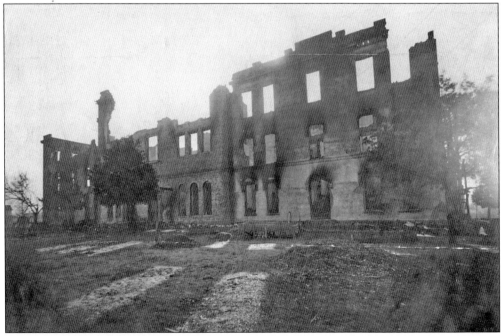

The main wing of the old main building was temporarily closed for renovation and expansion when it burned to the ground on January 21, 1913. Luckily, due to construction demands, all of the college's records, the library, the science laboratories, and much of the classroom furniture had temporarily been removed from the premises. The one hallway of classrooms in use at the time of the fire was a total loss.

Sherman Hall was built to replace the old main building. College officials dedicated it on April 8, 1915. One half of the ground floor contained the administrative offices of the college and, after 1922, the college bookstore. The other half comprised the library. Upstairs, the entire second and third floors consisted of a large auditorium that served as the meeting place for chapel exercises and for assemblies.

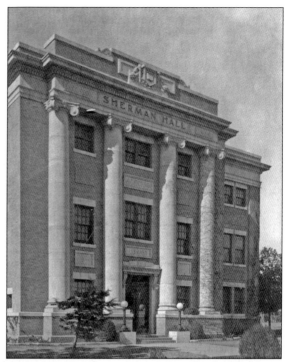

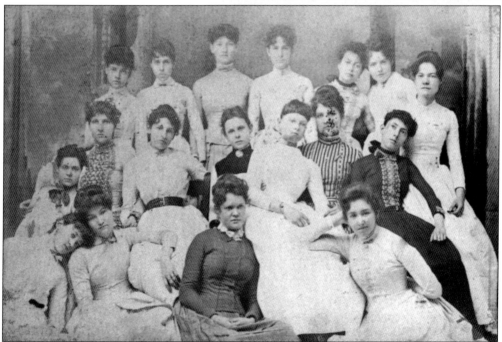

This picture shows a group of Kidd-Key College students in 1905. Students from Kidd-Key College, an all-female institution located in Sherman, often socialized with Austin College men in the years prior to World War I. By 1905, Kidd-Key students were regularly invited to Austin College for parties, entertainment, and special events. Kidd-Key College closed in 1935. By that time, Austin College had been admitting women for over 15 years.

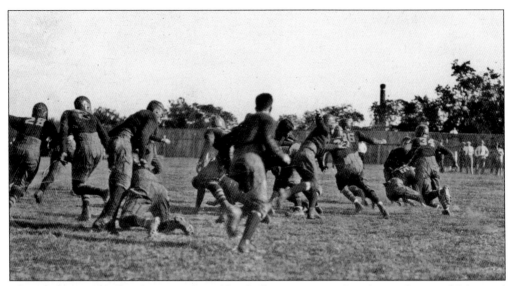

After Luckett Field closed in 1922, home football games were played at Cashion Field, located west of the campus in the present-day area of the College Green. This facility resulted from alumni donations. It bore the name of Mason Cashion, longtime director of the YMCA chapter. The field was enclosed by a fence and featured a large grandstand. Pictured is a 1925 game against East Texas State Teachers College.

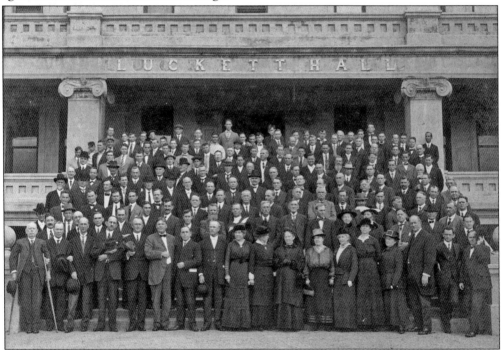

Until 1968, when Austin College became a legal entity separate from the Presbyterian Church, the Synod of Texas and its successors technically owned the college. Pictured here is a 1915 meeting of the Synod, an assembly that sometimes used campus facilities. The college was exclusively Presbyterian during the years of Dr. Clyce's leadership. All of the faculty and staff belonged to that denomination, as did most of the students.

With the advent of World War I, many students joined the college's Army Training Program unit, a forerunner of the modern ROTC. A number of them would eventually see active duty. Over 300 Austin College students joined this program between 1917 and 1919. In this photograph, a student dressed in his uniform takes a break while sitting on the porch of Luckett Hall.

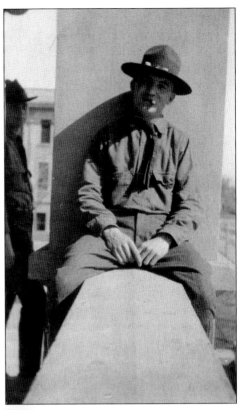

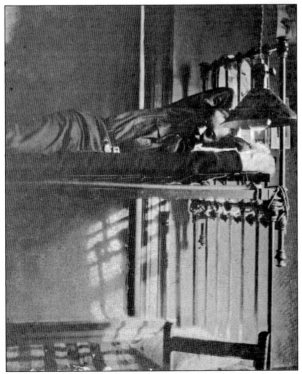

The college took on the appearances of an army camp during the Great War as the dormitory rooms doubled as barracks for the ATP unit. Student officers spent the summer of 1918 in military training that included the study of tactics, rifle range practice, and vigorous physical exercise. The Spartan iron beds of Luckett Hall no doubt provided welcome rest for the participants.

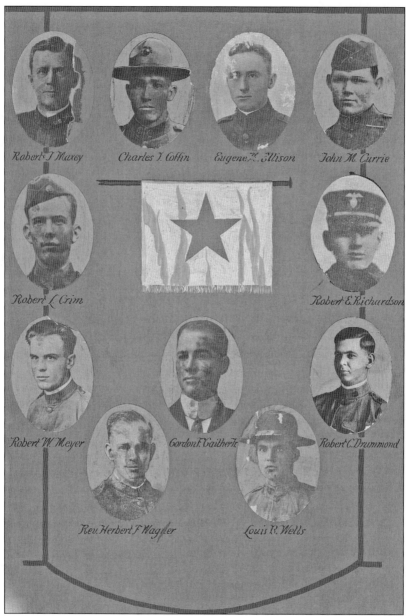

Robert J. Maxey
Charles J. Coffin
Eugene H. Ellison
John M. Currie
Robert L. Crim
Robert E. Richardson
Robert W. Meyer
Gordon F. Gaither Jr.
Robert C. Drummond
Rev. Herbert F. Wagner
Louis R. Wells

These Austin College students lost their lives in World War I. A grove of oak trees that still stands today along the sidewalk between the Dean and Baker Halls can be visited as their campus memorial. In 1919, M. B. "Grandpa" Reid, the groundskeeper at Austin College, planted these trees to honor the men. Formal ceremonies that year conducted by George Truett, pastor of the First Baptist Church of Dallas, dedicated the trees to their memory. Lt. Col. Robert J. Maxey had the distinction of being the most decorated Austin College student of the war. He attended the college from 1889 to 1891 during its Cadet Corps era, thereafter becoming a career army officer. Maxey fought with Theodore Roosevelt at San Juan Hill during the Spanish-American War and was later stationed in the Philippines. He commanded an infantry battalion at the Battle of Ypres and was killed in action on May 28, 1918.

Three

A PRESBYTERIAN COLLEGE
1918 TO 1948

President Clyce served as president until 1932 when he was succeeded by E. B. Tucker. Both men worked diligently to mold the college into a Presbyterian liberal arts college that would contribute to the religious mission of that denomination in the Southwest. An important milestone in that process occurred in 1918 when the college admitted women as full-time, regular students, thus becoming a coeducational institution. The exuberance of the 1920s brought a marked collegiate atmosphere to campus, while the difficulties of the Great Depression created a time of financial difficulty for the college, many of whose former students and alumni served with distinction in World War II.

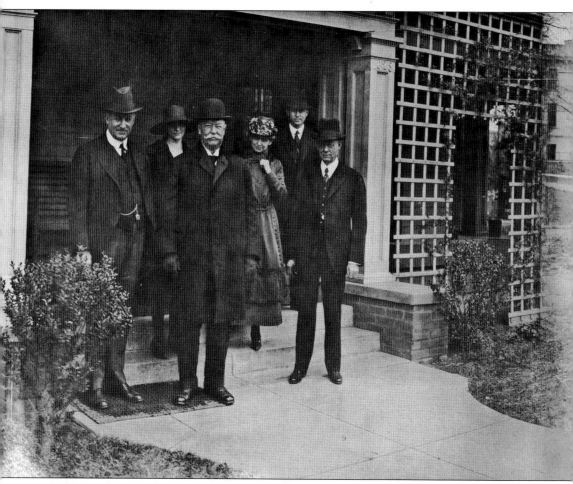

By the 1920s, Thomas Stone Clyce had a national reputation as a college president. He knew a number of prominent individuals, including former president William Howard Taft, a personal friend. The Tafts owned a ranch in Texas, and the former president sometimes stopped on his way there to visit Dr. Clyce. In this photograph, Taft (third from left) poses with the Clyces on the steps of their spacious home during one such visit. The Clyce family was gregarious and enjoyed entertaining campus visitors in their home. These included William Jennings Bryan; magician Harry Houdini (who performed on the stage of Sherman Hall); Confederate general John B. Gordon; famed newspaper editor Henry Watterson; opera star Anna Case; and several governors of Texas, especially Pat Neff, who was a special friend to the Clyces. Later demolished, the Clyce house stood on the southeast corner of Richards Street and Grand Avenue.

The Austin College Glee Club, formed in 1905, became a popular source of entertainment for the campus and the entire city of Sherman. The Glee Club made a tour of the north Texas area every spring. Each year, over one half of the student body would audition. The club's first director, George E. Case, served 33 years, not retiring until 1938.

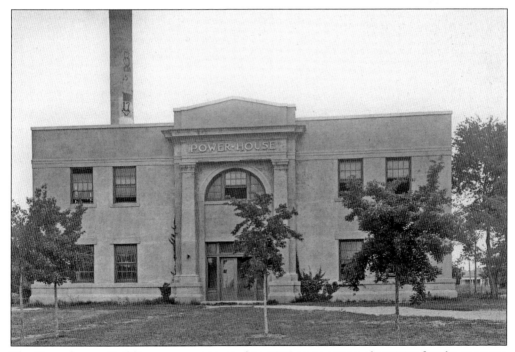

The Powerhouse Building was constructed in 1915 to generate electricity for the campus, but the machinery to do this was never installed due to lack of funds. Instead, the interior was fitted with flimsy wooden walls for use as classrooms and offices. It experienced a major upgrade in 1957 when it was renamed the Cern Building and became home to the Austin Teacher Program. The building was demolished in 2000.

The tall smokestack beside the Powerhouse Building was never fired up, but it did become a campus landmark. As such, it served as an important location for student graffiti. The seniors considered the smokestack their domain and routinely adorned it with their graduating year, as seen occurring in this photograph. College officials tore it down in the 1940s, worried about potential injuries. In its place today there is a television tower.

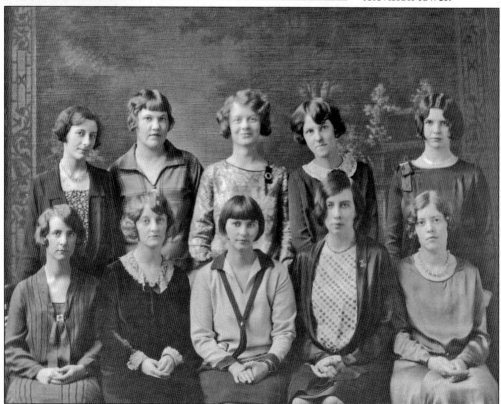

Pictured here is the Women's Executive Committee of 1928. Women first appeared at Austin College as special students in 1890. Dr. Clyce admitted the full-time women students in 1918, thus making the college officially coeducational. Within the year, several dozen had enrolled, and they began forming groups on campus including female literary societies and the Girls Council. The college gave them a lounge and reading area in Sherman Hall.

The Presbyterian Church maintained a summer encampment at Kerrville, Texas, where Austin College had its own clubhouse. It was a popular summer destination for students and faculty. In the early 1920s, Austin College closed its preparatory department in Sherman in order to be a completely collegiate institution. The students and faculty of the preparatory department moved to this encampment, which expanded to become Schriener Institute, now a university.

From the 1890s until the 1920s, some Austin College faculty members and students spent part of each summer at the Kerrville Presbyterian encampment, where they hiked, fished, participated in Bible study, and engaged in coursework. The encampment proved a favorite place for longtime English professor Davis F. Eagleton, who promoted its use by the college. This jaunty group appears particularly relaxed as they enjoy their time there.

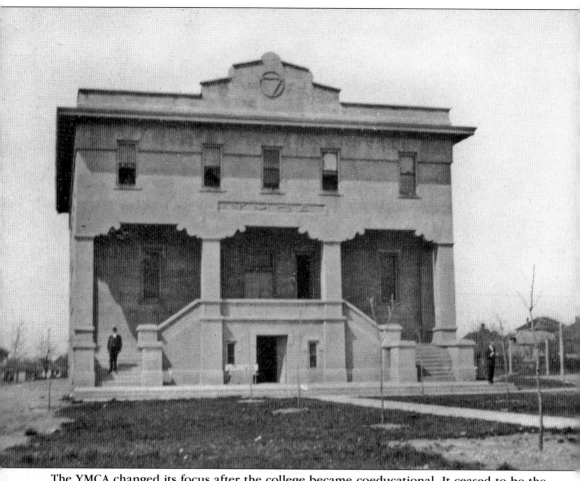

The YMCA changed its focus after the college became coeducational. It ceased to be the center of student social activity and existed as only of one many student organizations. Its building thus became a multipurpose campus facility that housed offices, meeting rooms, and classes. In the 1920s, the upper floor became the site of dormitory rooms where female students first lived on campus.

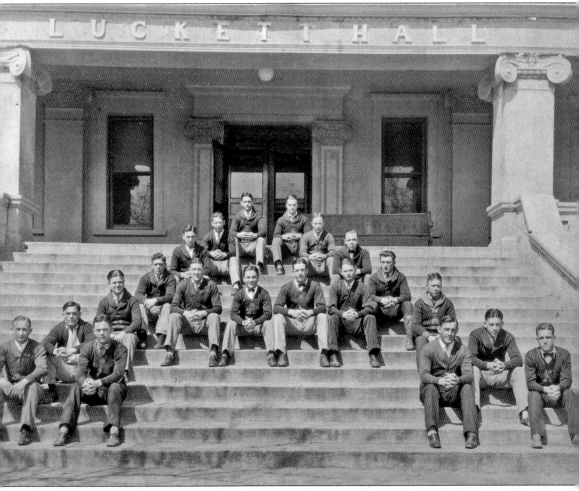

The 1920s witnessed the creation of many new student organizations, one of which was the "A" Association, composed of athletes who had earned team letters in baseball, track, tennis, football, and basketball. Members of the 1926 association pose on the steps of Luckett Hall. Each year, the group held a formal induction, which was an important event. The association also served as a social group, sponsoring dances and other entertainments. This organization has become one of the oldest and most venerable groups on campus. With the construction of the Hughey Gymnasium in the late 1940s, the association received its own meeting and trophy room known as the "A" room. This traditional space continued into the Robert T. Mason Athletic Complex when it was constructed. Since the late 1940s, the "A" Association has been completely coeducational. Each year, a gala Athletic Banquet highlights the contributions of its members on both the playing field and in the classroom.

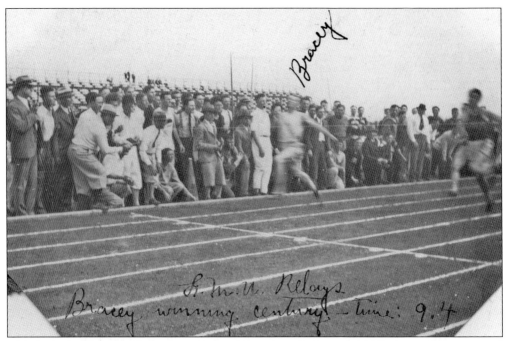

This dramatic photograph shows a 1920s track meet at Cashion Field. This sport first appeared at the college in the 1890s. Its zenith came in the 1920s, but track was eliminated for cost-cutting reasons during the 1930s. Resurrected in the late 1940s, the college regularly fielded men's and women's track teams until the early 2000s, at which time the program was again dropped when Austin College joined the NCAA.

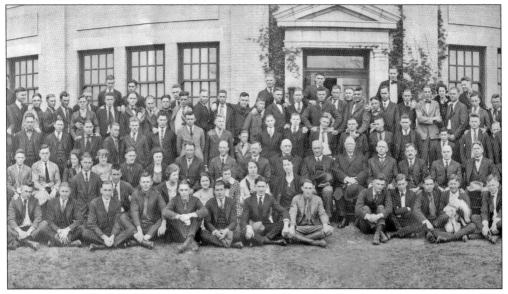

In the decade after World War I, the college was still small enough—with roughly less than 300 students—for the entire school to pose for a group photograph. Such an event occurred in 1920, when William Howard Taft appeared in the Sherman Hall auditorium to speak in support of the League of Nations. Taft sits between Dr. Clyce (left) and Robert R. Harwell (right) on the second row at the break in the seated line.

Austin College celebrated its 75th anniversary with ceremonies held in June 1924 during commencement exercises. Carried live over Dallas station WFAA, the event was the first statewide remote broadcast in the history of infant Texas radio. From left to right, Dr. Clyce; Ted Dealey, publisher of the Dallas *Morning News;* and Thomas M. Marshall, former vice president of the United States, are preparing to enter Sherman Hall for that event.

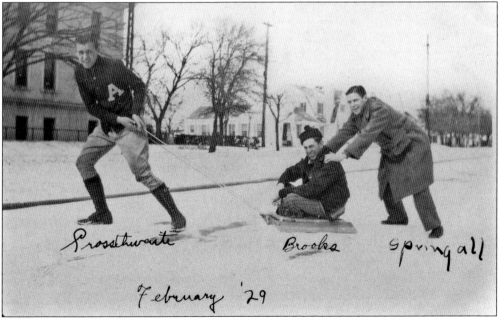

The Austin College archives contain hundreds of photographs of students playing in the snow from the 1870s to the present. Sherman receives an annual average of 3 inches a year, a Texas rarity. Snow is a great diversion—and no college history can have too many pictures of snow days—which give students chances to throw snowballs, make snowmen, and use makeshift sleds.

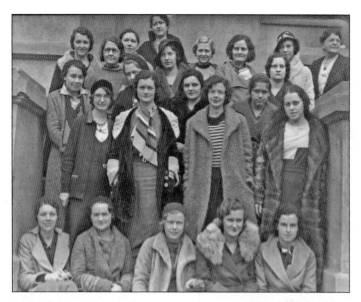

This 1932 photograph shows the women who belonged to the college's chapter of the Young Women's Christian Association, which had been created in the late 1920s to mirror the long-standing YMCA presence on campus. Both groups promoted Bible study and Christian service. In 1948, the two organizations united due to dwindling membership. In 1949, the college withdrew from YMCA membership entirely, and the organization restructured into the Student Christian Association.

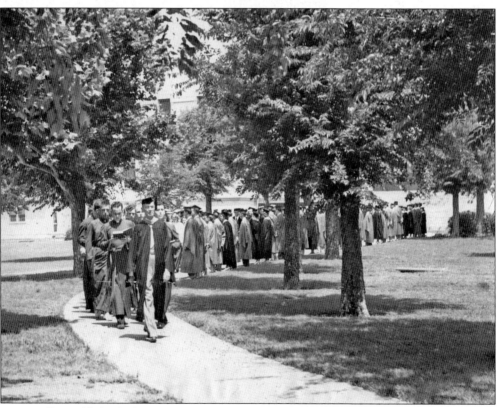

Dean Rollin Rolfe leads the graduation procession in this photograph. Rolfe was appointed Dean of Men in 1935. He was a major force on campus until his death in 1968. He believed that education of the whole person was extremely important. A number of amusing stories about his rigorous standards of etiquette and formal demeanor still circulate today, although modern students are unaware of the person behind them.

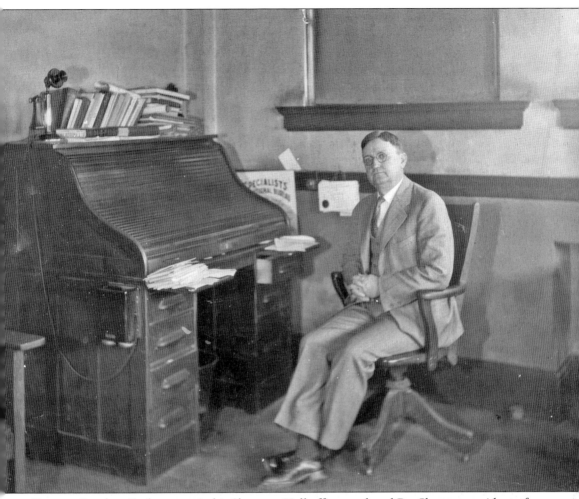

Everette Bracken Tucker, seen in his Sherman Hall office, replaced Dr. Clyce as president of Austin College on February 5, 1931. A 1905 graduate of Vanderbilt University, Tucker became president of Arkansas College in 1923. He assumed his position at Austin College during the difficult years of the Great Depression. Fund-raising and keeping the college open consumed most of his attention. He had three talented administrators to assist him: Dean James B. Moorman, who superintended the academic program; Dean Rollin Rolfe, the dean of men who managed the student life of the college; and professor of chemistry George Landolt, who also served as business manager. Dr. Landolt's stringent economies and creative financing in particular went great lengths towards saving the college. During the early 1940s, Dr. Tucker came to believe that Austin College should merge with Trinity University and create one Presbyterian institution. He clashed with the college's board of trustees, who believed otherwise and refused to do so. He was fired in 1943 because of this issue.

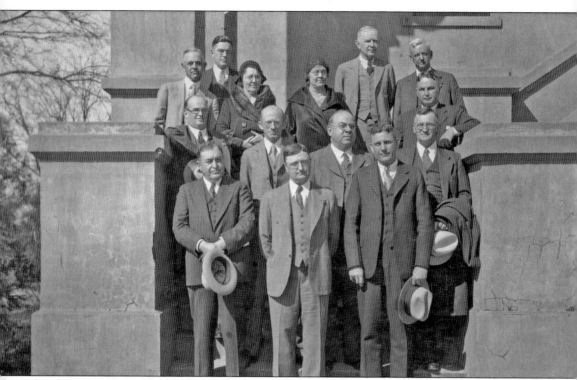

President Tucker poses with the board of trustees in 1932. In the first row, far left, is Chairman Pat Hooks, who was renowned as a 1890s football player at the college. A native of Itasca, Texas, Hooks was also active in the affairs of the Presbyterian Children's Home located near that town. As a result, Austin College and the Presbyterian Children's Home forged strong ties and, for many decades, young people who had grown up there attended Austin College on scholarships arranged by Hooks and his friends. In the back row (second from right) is P. B. Hill of San Antonio, who served as chaplain to the Texas Rangers. He was a well-known and colorful personality because he wore a ranger badge as the chaplain, occasionally participating in their law enforcement exploits while serving as pastor of the First Presbyterian Church in San Antonio. Hill's son David graduated from Austin College in 1938 and won fame with the Flying Tigers in China.

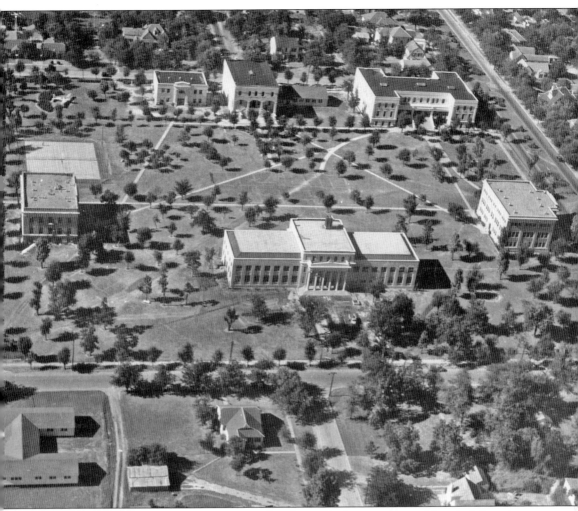

This aerial view shows the campus as it existed in the 1940s. Construction of the administration building began in 1925 but remained unfinished for 20 years, and the structure stood empty during that time. It was known as the "Skeleton Building" because the steel superstructure could be seen, since there were no outside walls. Students occasionally played nighttime pranks by hoisting things such as live cows or faculty members' automobiles onto the open-air upper floors. Along the top of the photograph, right to left, are Luckett Hall, the YMCA Building, and the Powerhouse Building. All have been razed. Only the Caruth Administration Building, Sherman Hall, and Thompson Hall are recognizable as part of the modern campus. Cawthon Gymnasium, a frame building, can be seen in the lower left at its current location of Clyce Hall and the College Green. In the northwest corner of the campus, the current location of Baker Hall, stood the Kangaroo Cemetery, where students laid to rest the live mascots when they died.

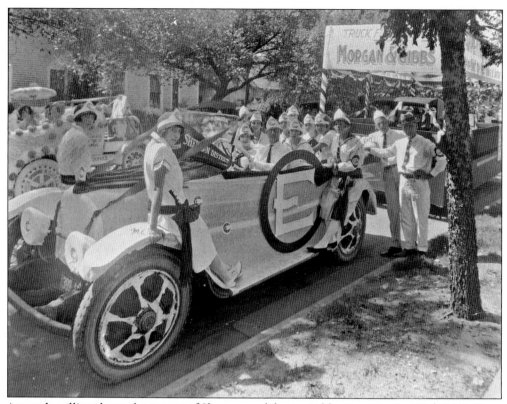

A parade rolling down the streets of Sherman celebrates Eddie Dyer Day in 1926. Eddie Dyer was on the Austin College coaching staff during the 1920s, and he played for the Saint Louis Cardinals baseball team from 1922 through 1927. The celebration of Eddie Dyer day was due to the Cardinals' 1926 World Series victory against the New York Yankees.

Arriving in 1922, a young biologist named James B. Moorman came to the college with a concept of the liberal arts that eventually reshaped the curriculum. Personable and fair, Moorman was loved by both students and faculty. Named academic dean in 1935, Moorman served until 1960, thereafter remaining in the biology department until his death in 1974. Everyone, including his wife, simply referred to him as "the Dean." He played a significant role in creating the modern college.

Four

A LIBERAL ARTS COLLEGE FOR TEXAS

1949 TO 1978

The post–World War II years witnessed growth and expansion for Austin College. An influx of veterans supported by the G.I. Bill temporarily swelled the ranks of the student body during the late 1940s. John D. Moseley succeeded William B. Guerrant as president in 1953 and launched the college into a new era of prosperity. Dr. Moseley oversaw an aggressive building program that modernized the college's physical plant. He also secured significant grants from sources, such as the Ford Foundation, to revamp the curriculum. He secularized the college by removing it from the auspices of the Presbyterian Church, an action that occurred in 1968. By the time John D. Moseley retired in 1978, these changes had earned Austin College great respect throughout the nation as an innovative private liberal arts college.

Dr. William B. Guerrant assumed the presidency of the college in February 1943. He received a master of arts degree in English from Centre College, a bachelor of divinity degree from Louisville Theological Seminary, and a doctorate in Sacred Theology from New York City Theological Seminary. Guerrant implemented a number of changes to stabilize and finance the school during the war. He introduced war-training programs while a cadet nurses training program operated in cooperation with Wilson N. Jones Hospital. Several facilities were opened on campus to house the Texas Home Guard and the Naval Reserve. A flight-training unit filled Luckett Hall and portions of the Y Building with cadets. After the war, he tirelessly led successful fund-raising campaigns to build Hughey Memorial Gymnasium, Memorial Student Union Building, Adams Health Center, and to complete the administration building. In 1949, Dr. Guerrant helped Austin College celebrate its centennial. He retired in 1953.

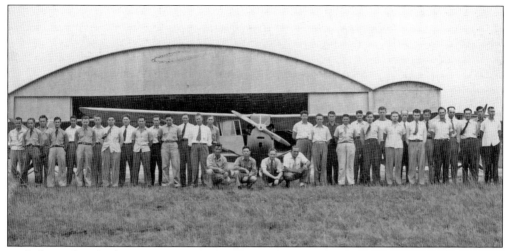

With the outbreak of war in Europe during 1939, the U.S. government moved quietly towards preparedness. In August of that year, the college joined the Civilian Pilot Training Program. Most male students enrolled and learned to fly. George Landolt directed the program, while other faculty members taught meteorology, radio communication, and codes. Not surprisingly, a considerable number of students served in the Army Air Corps during the war.

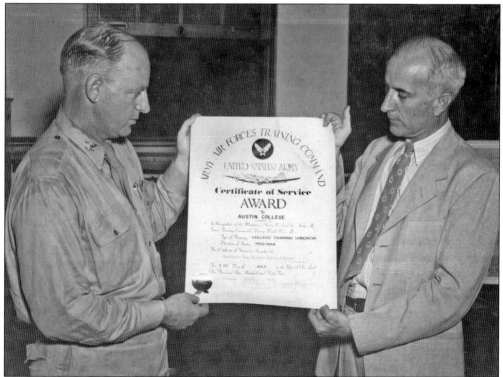

During World War II, the college campus served as the training facility for the 77th Flight of the Air Training Command. Members of this unit lived in the dormitories during training, which took place in campus classrooms. This kept the college functioning, since by 1944 there were only 75 regular students, mostly female. In this photograph, W. B. Guerrant accepts a certificate of appreciation from the U.S. War Department for this activity.

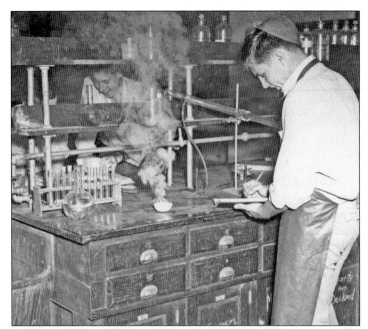

The end of the war brought large numbers of veterans, many of whom had seen their college educations interrupted, back to campuses across the nation. This influx revitalized Austin College, and the student body expanded exponentially in the late 1940s. Many of the students at Austin College gravitated to pre-medical studies and health professions. The students in the photograph are working in the science laboratory of Thompson Hall.

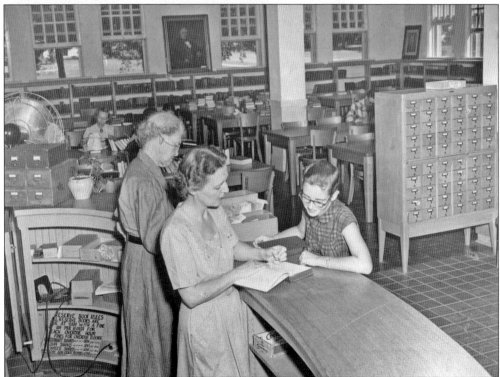

Mrs. Edwin Lewin (rear) and Dorothy Womack (front), librarians, assist a student in the Sherman Hall Library, which was expanded in 1947 when the administration building was finished. In the postwar period, the college faculty adopted the University of Chicago Great Books Program as the basic humanities curriculum. This demanded a much greater amount of library work for students, since all of them read historical texts and documents.

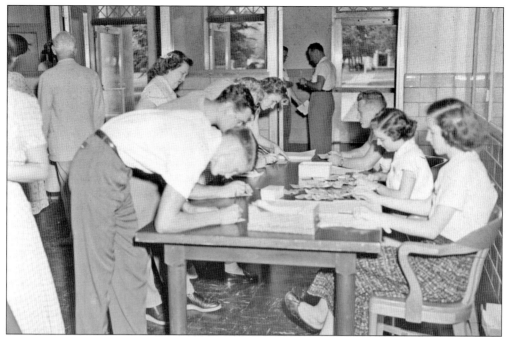

President Guerrant's first order of postwar business was to complete the administration building, which was finished in 1947. Since the late 1920s, the empty framework of the building had sat in the middle of the campus. The students pictured here are completing the first registration held in the new administration building. Dean Moorman, facing away from the camera in the background, is seen dressed in a white suit.

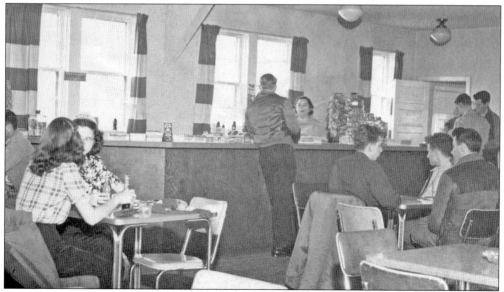

College officials installed this snack bar in the basement of Luckett Hall after the war. It became the most popular gathering spot on campus. Luckett, which also contained the dining hall and the mail center, soon became so cramped that Dr. Guerrant and the board of trustees pledged to build a student union on campus. The Student Union Building, located on College Street, opened in 1952.

Pat Hooks, an outstanding alumnus of Austin College, received an honorary degree during the college's centennial year celebration in 1949. Chair of the board of trustees, the greatest contribution of Hooks to the college was convincing the Presbyterian Synod not to close the school during the darkest days of the Depression in 1932. An influential banker, he explained to the synod the complicated credit structures that permitted the college to remain open.

Coffin Hall, completed in 1948, was the first residence hall exclusively for women. It was divided into suite-style living areas, with individual rooms clustered into sections with their own bathroom facilities. The building housed 65 women and had a first-floor lounge with a grand piano, which proved a very popular place for social gatherings. Coffin Hall was razed to make room for the Wright Campus Center.

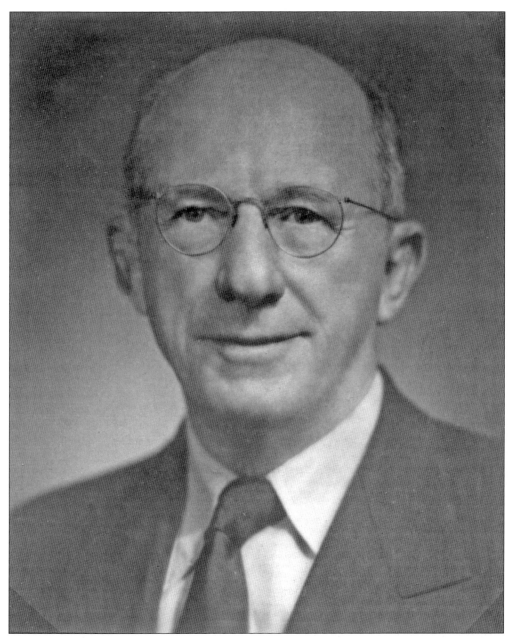

Alumnus Hoxie Thompson was a college trustee and one of Capt. J. M. Thompson's four sons, all of whom attended Austin College. The Thompson family proved to be generous with the college, donating Thompson Hall in 1913. In addition, the family gave their Grand Avenue home to the school and Hoxie contributed to the building of Sherman Hall, where the auditorium bears his name. Hoxie Thompson Auditorium was the location for the college's chapel services from 1914 until Wynne Chapel opened. In later years, held twice a week on Tuesday and Thursday mornings at 11:00 a.m., the chapel brought visiting preachers and religious speakers to campus as a regular part of the worship service. The auditorium has been modernized into a space half its original size and today is used for classes or guest speakers. Hoxie Thompson's portrait hangs by its main entrance.

71

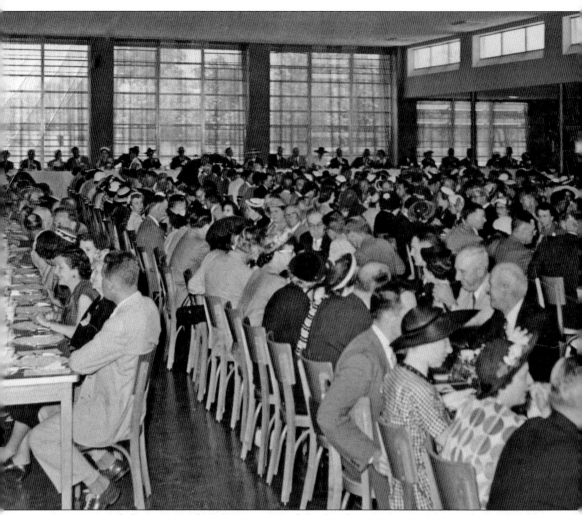

Guests attend the opening banquet as part of the Student Union Building's dedication on May 26, 1952. The SUB, as it popularly came to be known, had a modern cafeteria, formal lounge, postal center, snack bar, and meeting rooms. It was dedicated to all of the alumni who had lost their lives in American conflicts up to its completion. The SUB stood on the current location of the College Green. When constructed, the main dining room was large enough to seat all the students and faculty at one time. By the 1960s, this was no longer the case; the building was expanded on two occasions before being replaced by the Wright Campus Center. The Green Room was a dining area with formal dinnerware and tablecloths. It operated two nights a week as a restaurant with menus. Students could eat there on their meal plans with advance reservations, but had to dress semiformally. The Green Room and its smaller counterpart, the Gold Room, became preferred locations for many college banquets.

In the era before television, Austin College students got much of their entertainment and news from radio. All college dormitories and lounges had large console radio sets. A number of the college's students worked for Sherman station KRRV as on-air personnel and also behind the scenes. This photograph shows an Austin College student operating the main broadcasting board that switched programming between the local studio and network radio feeds.

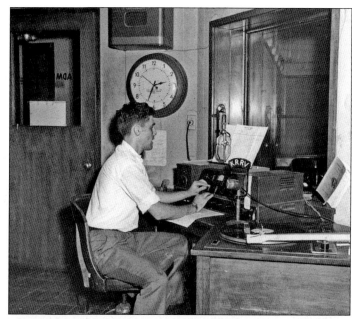

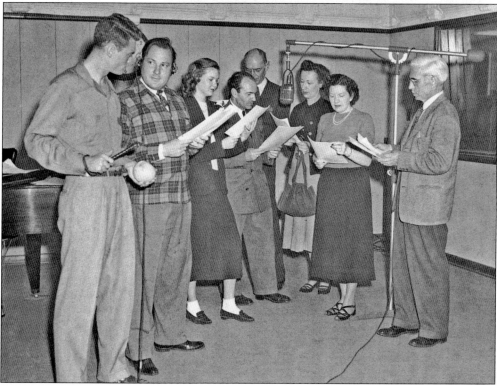

Dean Rollin Rolfe wrote a series of radio plays for the 1949 college centennial that were broadcast statewide by the Texas Quality Network. Dean Rolfe is seen partially obscured in the background. Robert Bedford, the choir director, stands in front of him. Dean James B. Moorman is the man at the right, while his wife, Elizabeth, is speaking into the microphone. Two students at the left are making sound effects.

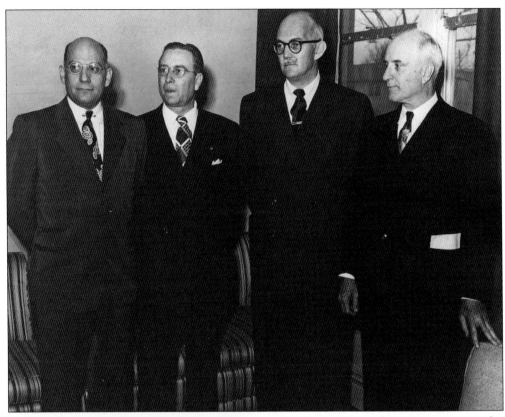

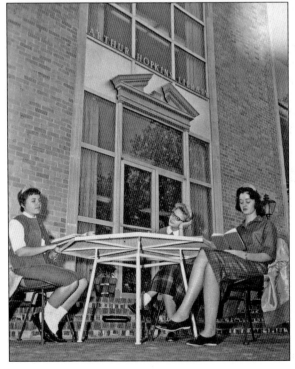

By the late 1940s, wartime Texas oil discoveries, coupled to urban growth and industrial expansion in the state, created new areas of support for the college, especially among Presbyterian laypeople. Pictured here are three individuals who became generous supporters of the college, from left to right, Elmer Danner, L. L. Herdus, and Cedric Rose. At the far right is W. B. Guerrant.

These students are reading on the patio of the Arthur Hopkins Library Center. Opened in 1960, the library eventually held over 200,000 volumes along with the Heard Rare Books Room. Hopkins was the first building dedicated solely to housing the college library. By 1986, the building was too small for the collection. With the donor's permission, it was remodeled as the Arthur Hopkins Center for the Social Sciences.

John D. Moseley became president on September 1, 1953, and remained until the summer of 1978. His wife, Sarah Bernice, would become as much a campus fixture as he was during the years of his leadership. Graduating from East Texas State University, he later earned a law degree at the University of Texas. Moseley brought his experiences from serving the Office of Price Administration and the Texas Legislative Council to the presidency. His presidency witnessed the college become nonsectarian with great innovation in administration, the academic curriculum, a spectacular physical expansion of the campus, and growth in all areas of campus life. The college adopted a new curriculum, placing it on the frontiers of higher education with emphasis on international experiences and interdisciplinary learning. He oversaw a peaceful and successful racial integration of the school and significantly increased the number of female professors. Serving as chancellor until 1981, John D. Moseley left a legacy that created the modern institution.

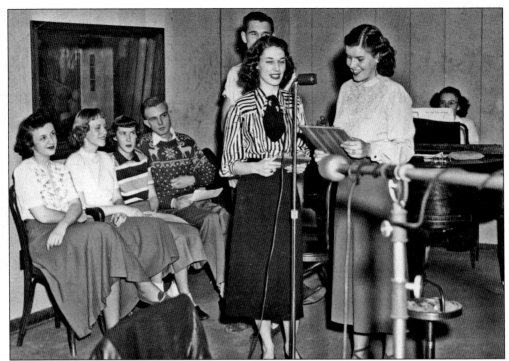

Radio continued into the 1950s as a major feature of campus life. Students regularly broadcast class projects. The college thus became known for its academic programs in communication arts and established one of the earliest such majors among liberal arts colleges. As radio passed into history, the school turned to television and film, which was reaffirmed with construction of the Ida Green Center in 1972.

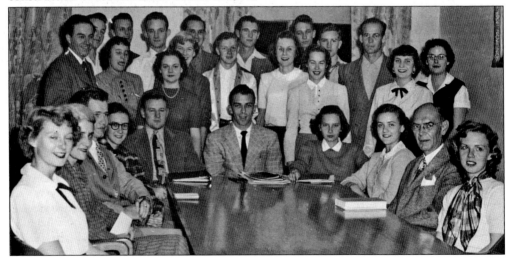

Members of Student Council from the mid-1950s are pictured here with Dean Rollin Rolfe (seated second from the right). President Moseley made successful efforts to give the student body significant opportunities for self-government in all areas of campus life. Eventually he created a system known as "Program Management" that placed students on all committees of the college. This included the academic departments and a college-wide master group called the "Governing Council."

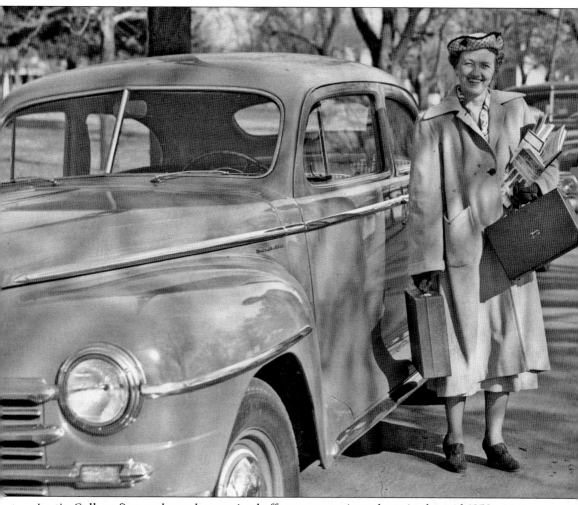

Austin College first undertook organized efforts to recruit students in the mid-1950s. Mary Foulks (pictured) was the college's first recruiter. By 1960, she had logged 150,000 miles on her Chrysler sedan while meeting with prospective students at high schools, Presbyterian churches in the state, and at summer youth events. By that time, the college had begun to employ professional recruiting personnel, most of whose efforts initially focused on Presbyterian youth. With the arrival of the 1970s and the college's growing reputation, college admissions representatives found the suburban areas of Southwestern cities to be promising areas where students had an interest in the college. Today, although Austin College is located in a relatively small city, the majority of students come from the larger urban areas of the region. Not surprisingly, given these developments, the student body expanded from less than 300 in 1953 to 1,200 in 1978, during the years that John D. Moseley served as president.

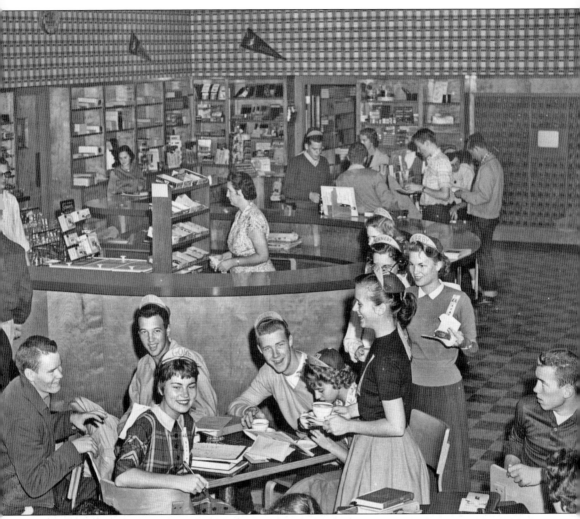

The Student Union Building was the undisputed center of campus life from 1952 until the opening of the Wright Campus Center. Pictured is the campus snack bar and store as it appeared in 1956. The horseshoe bar, with its ice cream and made-to-order "jerked" sodas, proved a memorable feature. Pictured in the foreground are students wearing "slime caps," thus denoting them as members of the freshmen class. A noteworthy moment came when the college opened a campus bar serving beer and wine in 1978. The former snack bar was remodeled with wood paneling and dimly lit booths, and the students enjoyed its subdued and warm atmosphere. The Pub, as it became known, was a popular place for visiting musicians, comedians, and entertainers to perform. It also became the location for sorority and fraternity dances. By the 1990s, because of the college's kangaroo mascot, the Pub had an Australian theme to its decoration.

The main living room of the Union served as the central crossroads of the campus. A grand space encompassing almost 5,000 square feet, it contained comfortable and homelike furniture. It served daily as a study room where students also relaxed, and it was the most popular venue on campus for receptions, teas, and official college entertainments. Remodeled several times over the years, it always welcomed student and faculty interaction.

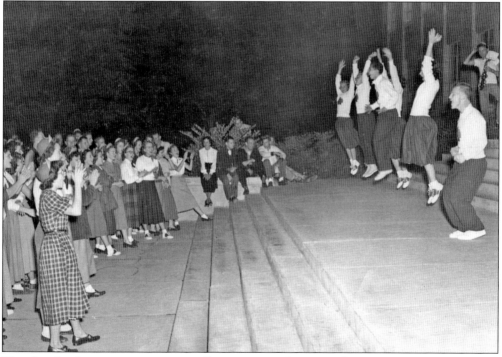

The cheerleaders motivate Austin College spirit on the steps of the administration building in front of an audience of freshmen "slimes." The 1950s and 1960s saw the campus become a pleasing home to a growing number of students when new residence halls opened. This greatly increased school spirit, as the scope and variety of campus activities grew tremendously, thus making the enhanced student life very "collegiate" in nature.

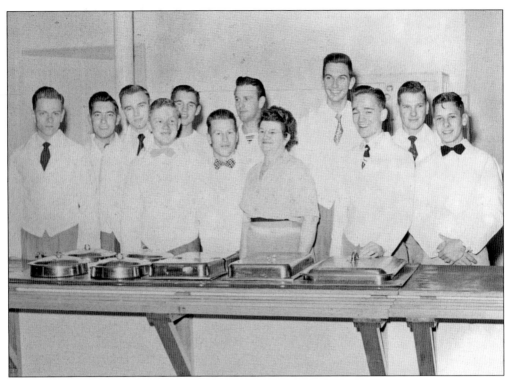

Mr. and Mrs. James Fagg operated campus food services as beloved campus personalities in the 1950s. Affectionately known as "Ma and Pa," he directed the kitchen, while she supervised the dining room. Many a student unburdened their problems to Mrs. Fagg, who was a patient listener and a firm friend to all. She is pictured with a group of student waiters, including current trustee Robert Johnson at far left.

Expansion of the physical plant during the Moseley era followed a master plan including a commitment that all new buildings would be architecturally harmonious. Architect Peyton G. Cooper designed most new contruction from the late 1940s to the 1960s. He articulated the blond brick, deco-influenced, and austere neoclassical architecture that defined the new campus. Pictured is the Hopkins Library, which helped to define this unique design.

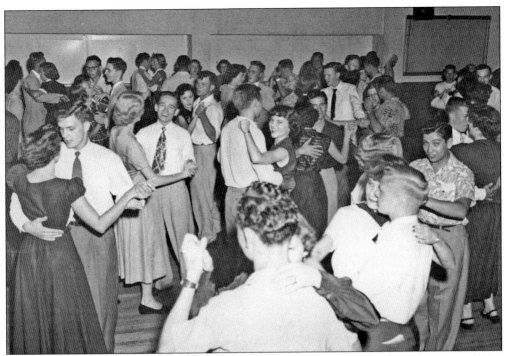

Students in the 1950s attend a campus-wide dance in the basement of the YMCA building, not demolished until the 1960s. Many student groups organized a special dance each year as a fund-raiser. They proved especially popular for the college's fraternities and sororities, all of which were local because the college did not permit national ones. The homecoming dance, the Alpha Delta Chi Ski Lodge, and others became campus traditions.

The annual homecoming dances of the 1950s and 1960s were very formal affairs, as pictured in the main dining room of the SUB. Students of that era regularly dressed more formally than they do today. In classes, women wore skirts and blouses; the men wore dress slacks and shirts with collars. Extracurricular events, other than athletic ones, called for sport coats and ties for the men, and dresses for the women.

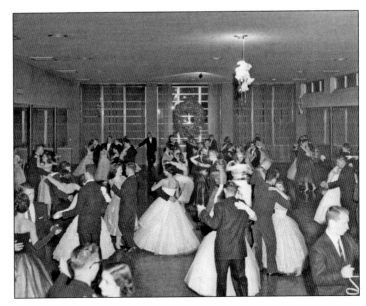

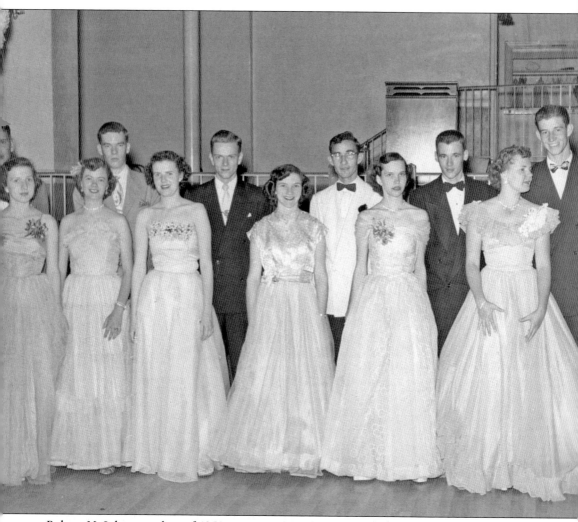

Robert M. Johnson, class of 1953, appears third from the left in the back row in a group of students attending a formal dance. Johnson, who was particularly influenced in his student years at Austin College by professors Paul and Bonnie Beardsley, enjoyed a successful career in media management and documentary filmmaking. At the time of this writing, he serves as chair of the college's board of trustees. The Johnson Roo Suites are named in honor of Mr. Johnson and his wife, Joyce. This facility is the newest residence hall on campus, made necessary by the demolition of Luckett Hall. The Johnson Roo Suites contain apartment-like arrays of single rooms that are connected to small lounge areas shared by four bedrooms. Commons baths connect every two-lounge pods, thus making for a very human scale of living, far different from the traditional dormitories prevalent during earlier eras of the college's history.

Ray Morrison, center right in the overcoat, accepts an honorary football letter jacket. In 1949, he turned down the head football coaching position at Yale University in order to lead the Kangaroos, which he did for four years. He proved to be a very popular coach with a solid record. Morrison was one of the last football coaches under the athletic scholarship program, which Dr. Moseley ended. Non-scholarship athletics proved controversial at the time since some alumni balked at the change. It likely also played a role in Coach Morrison leaving the college. Nonetheless, Dr. Moseley wanted only athletes who would be students first and players second, so all athletes had to qualify for academic scholarships. The scholar-athlete quickly became the standard for the college's intervarsity sports program and that standard has been upheld until today under NCAA Division III.

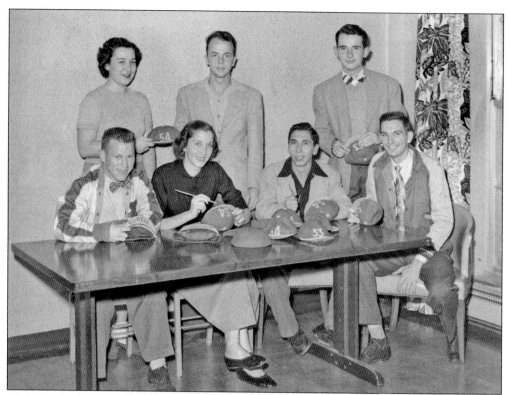

These students are decorating freshmen beanies during the 1954 school year. Until the 1960s, all freshmen wore beanies when they appeared in public on campus. This tradition went back to the 1920s, and was widespread in earlier eras of higher education throughout the nation. Austin College was one of the last to drop this practice, which was a very popular local tradition.

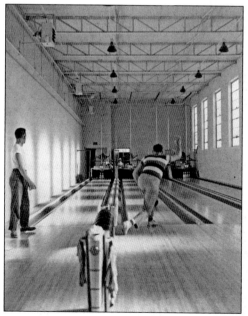

Bowling was a popular student activity prior to the 1970s. Sherman and Denison had alleys, as did the campus. This last bowling alley on campus, located in the Sid Richardson Center, opened in 1971. After a few years, however, the sport's popularity declined with students and the space became a dance studio, finally disappearing completely with the renovations that created the Robert T. Mason Athletic Complex.

The years of Dr. Moseley's leadership saw the expansion of various international programs involving foreign students attending the school, while Austin College students increasingly enjoyed experiences in other countries. The growing ease of passenger air travel, coupled with the rise of Dallas as a major airline center, assisted the development of these programs. Mary Foulks, college admissions officer, is seen at Dallas's Love Field welcoming an international student.

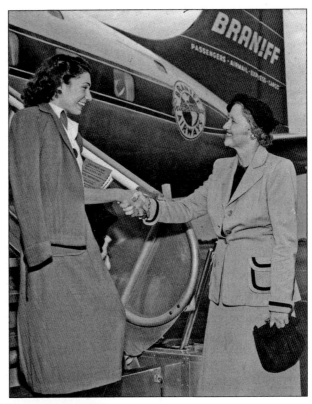

Local Greek organizations became very popular during the Moseley years. At its highpoint, the college had 10 fraternities and seven sororities, although the numbers have declined. Each year, on the second week after spring break, pledges paint logos and mottos of their organization on the sidewalk between Sherman and Dean Halls, and formerly the YMCA, as pictured from the early 1960s.

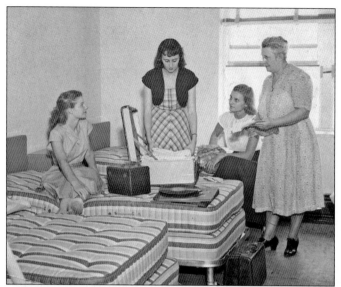

Freshman weekend has always been an exciting time as new students arrive to begin college. Prior to the implementation of Communication Inquiry in the late 1960s, residence halls served as centers for orientation. Until the 1980s, female matrons (usually of retirement age) supervised the women's dormitories. In this photograph, these freshmen women meet the Coffin Hall matron as they settle into their room. Note that three students shared one room.

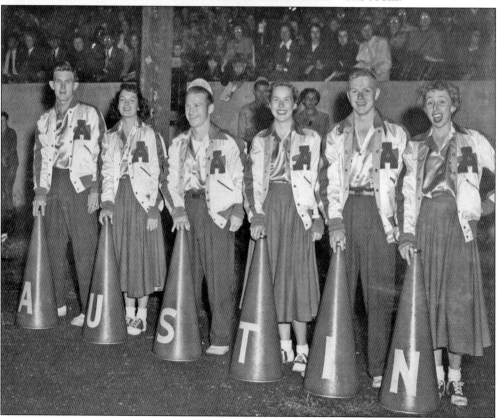

Austin College has had cheerleaders since the 1890s, although all male until the late 1940s. Since then, squads have been balanced with men and women. In the 1990s, a group of female students organized a spirit-oriented dance team known as the Aussies. They regularly perform at football and basketball games to recorded music, since the college has not had a marching band since the 1950s.

"Katie the Kangaroo" is the official college mascot. Until the mid-1950s, the cheerleaders kept a succession of Katies (real kangaroos) who routinely appeared at events and who lived in a kangaroo kennel on campus. Several of these former Katies are now buried in unmarked campus graves. The Katie theme seen in this photograph on the float passing through downtown Sherman in the homecoming parade parodies the 1950s musical comedy *Annie Get Your Gun*.

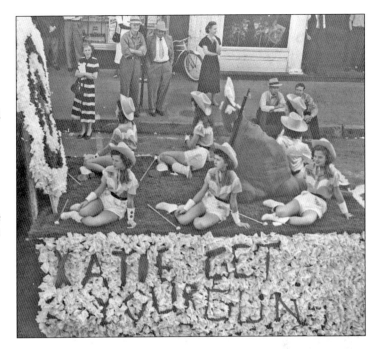

Wynne Chapel was dedicated on September 15, 1958, for use by Austin College's mandatory chapel program that required documented attendance by all students. During the 1960s, however, non-sectarian viewpoints became increasingly commonplace. The academic year 1965–1966 witnessed stirring debate regarding the college's mandatory chapel. The administration decided on voluntary attendance. Within a few years, weekly chapel ceased, although the building is still home to a vibrant interdenominational religious program.

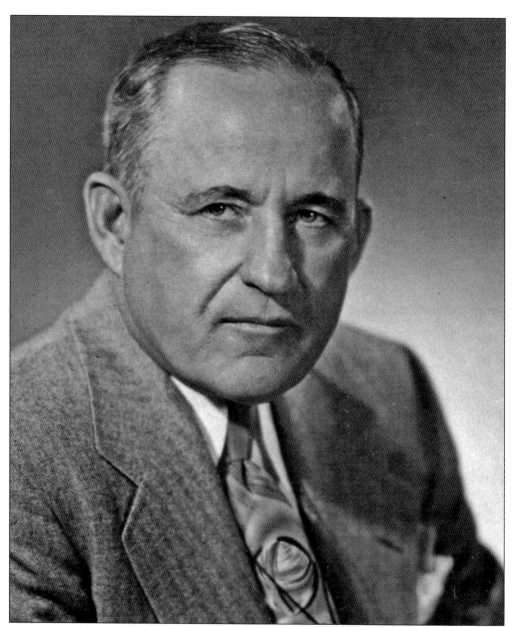

Toddie Lee Wynne (1896–1982) was a successful Dallas oilman, developer, and businessman who contributed to the growth of the Metroplex in the mid-20th century. A Presbyterian lay-leader, John D. Moseley recruited him as an important supporter of the college. Mr. Wynne served as chair of the board of trustees for much of the Moseley presidency. He made many contributions to the college, one of which was Wynne Chapel. Starting in the late 1950s, he also helped Dr. Moseley interest other civic and business leaders from the expanding Dallas/Fort Worth area in serving on the college's board of trustees. Prior to that decade, trustees were predominantly Presbyterians attracted by their denominational commitment. A growing number of individuals from many walks of life and diverse backgrounds routinely began serving the college as trustees, in large part thanks to initiatives begun by Mr. Wynne and Dr. Moseley.

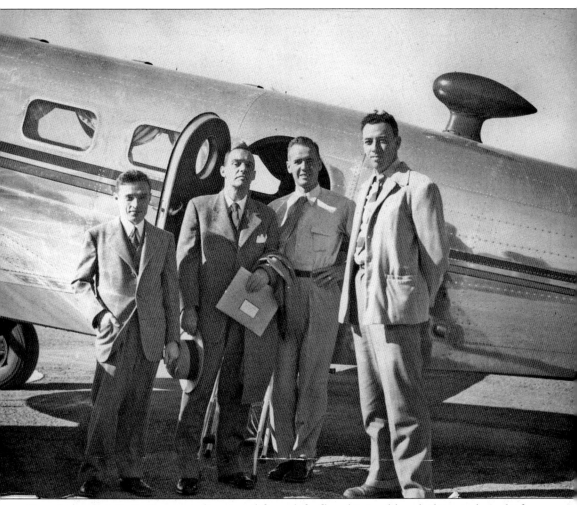

Board member R. R. Farnsworth, second from left, flew his Lockheed plane to board of trustees meetings. Other trustees also preferred private aircraft, including Toddie Lee Wynne, who maintained a Douglas DC-3 passenger plane for personal use throughout the 1950s and 1960s. This was the same type of aircraft used by the airlines. To encourage attendance at board meetings, Mr. Wynne sometimes flew around the region in his DC-3 gathering trustees who then arrived in Sherman aboard his plane. This was made necessary because of the relative isolation of Sherman, linked only by a two-lane highway system to the much smaller cities in the region at that time. Up until the early 1960s, the Sherman Municipal Airport had regularly scheduled passenger airline service to Dallas and Oklahoma City. The growth of the Metroplex, coupled with a burgeoning expressway system, has made Sherman a convenient part of the expanding north Texas metropolitan area. Students routinely today seek recreation in the form of shopping, movie theaters, and other entertainments in the urbanized Metroplex.

For many years a small frame building, "The Annex," stood between Luckett Hall and the YMCA until it was demolished for the construction of Dean Hall. As seen here, sororities and other groups used The Annex and the basement of Luckett Hall for social functions. The Annex was the last wooden building on the main campus used for student activities, although several converted army barracks stood along Brockett Street for overflow storage and offices until the late 1970s.

The Austin College A Cappella Choir was founded in 1942 by Mrs. Paul Silas, seen in the center of the photograph. Robert Wayne Bedford, its first professional director, established many of its enduring traditions. The group made its first international tour in 1957. Under Bruce Lunkley, a subsequent director, the choir earned a national reputation from radio, television, and personal appearances, in addition to participating in many official college ceremonies.

The Crossroads Africa program, founded by James Robinson in 1957, came to Austin College in 1962 after student Larry Hedges participated in the program on his own accord during the summer of 1961. The students pictured here won scholarships in 1962 to participate in this program, one of the college's early international study opportunities. Crossroads Africa sponsored an annual campus auction into the 1980s that raised money for this activity.

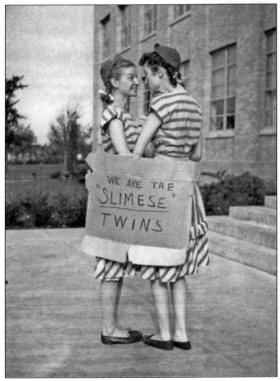

These late 1950s-era "slimese twins" were freshmen engaging in an activity of the "Slime Association," an informal group that banded new students together, and once an important part of becoming a fully accepted member of the student body. Its activities involved what students of the 1950s and early 1960s saw as harmless hazing by upperclassmen, which sometimes required freshmen to engage in embarrassing behaviors.

By the 1960s, the growth in financial support permitted the college to increase the number of fellowships and scholarships available to promising students. The winners of the 1963 Troy V. Post Scholarship, seen in this photograph, were examples of the high-caliber students Austin College was attracting. Then as now, many of these students posed for photographs to be used in the college's publications

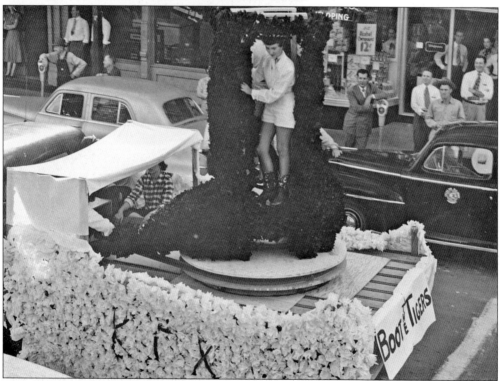

The annual homecoming parade has been a campus tradition for almost 70 years. Until the late 1960s, it took place in downtown Sherman, as seen in this photograph. It later moved to streets surrounding the campus, starting on Richards Street, following Grand Avenue, and onto Brockett Street. Students also began throwing candy. In the early 2000s, the parade left the streets entirely and became a golf cart procession on campus.

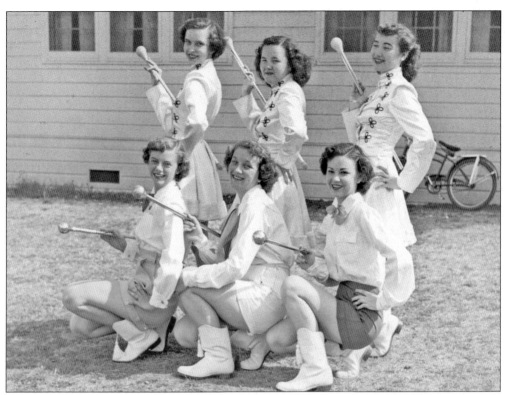

The Austin College marching band disbanded in the 1950s, thus making the college one of the few in Texas without one. The majorettes pictured were among the last in the history of the college. Over the years, however, ad hoc groups of student musicians have sometimes organized informal bands that sit in the stadium during football games to play collegiate pep songs and raise the spirit of the crowd.

By the 1960s, the convocation program (which descended from the chapel exercises by taking its weekly time slot) brought religious and secular speakers to campus. Richard "Dick" Gregory appeared as the first African American speaker in the convocation series. Known for his comedic and satirical attitude towards social and political issues, Gregory seriously attempted in his work to improve race relations while ending hunger, violence, and drug abuse across the nation.

By the 1960s, basketball rivaled football in popularity. Robert T. Mason, an alumnus, became the coach in 1961, and continued in that position for 35 years. In 1964, the team played against Midwestern State in one of the most exasperating games ever seen in Hughey Gymnasium. Coach Mason decided to use the "stall tactic" whereby the Kangaroos played slowly to minimize scoring. For much of the game, the score remained 1-0.

In the 1950s, the Ford Foundation provided a large grant to Austin College for reexamining its curriculum. This resulted in "The Austin College Plan," centering on academics, religious instruction, and cocurricular activities. This eventually led to the establishment of Basic Integrated Studies courses followed by what was later known as the Heritage of Western Civilization (HWC). HWC involved large lectures and small discussions with faculty members, such as the one pictured.

Sam Rayburn represented the college's congressional district from 1913 until 1961. A firm friend of the school, he regularly appeared on campus and was present at the dedication of Hughey Gymnasium (second from right). History professor Edward Hake Phillips, who served on the faculty from the late 1950s until the early 1980s, knew Mr. Sam personally and forged strong cooperative relationships with the Sam Rayburn Library and Museum in Bonham that still exist today.

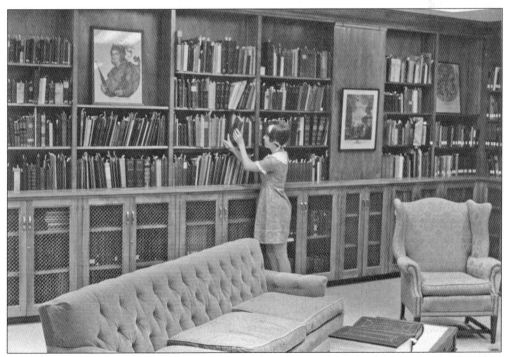

A student library worker shelves items in the Heard Rare Book Room of the Hopkins Library in 1968. The college developed strong collections dealing with Texas and the southwestern United States, purchasing such material on the library market for over a century. Significant special donations of collections and funds from the Heard-Craig family of McKinney, the estate of alumnus Rex Strickland, and the Erwin E. Smith Foundation strengthened the collection.

Racial integration came quietly and peacefully to the college in the early 1960s. Exchange students sent from Africa to the United States by Presbyterian missionaries were the first to cross the color line, enrolling as full-time students and living in the residence halls starting in the fall semester of 1960. Shortly thereafter, African American students began attending without incident. The first full-time African American professor joined the mathematics department in 1972.

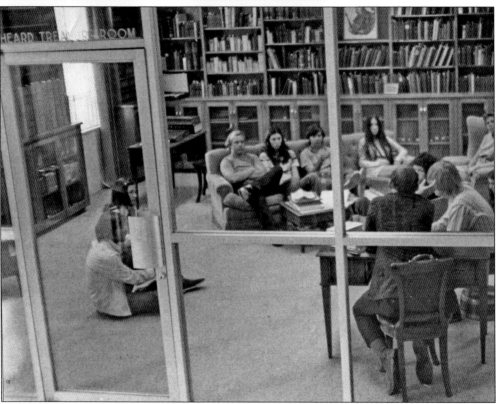

In the early 1970s, the college implemented curricular revisions that produced broad-based changes known as the ideas (IDEAS) program. This involved students meeting with personal faculty mentors, the institution of the January term, an innovative fall semester calendar, the move to unit credits rather than semester hours, and Communication Inquiry classes for all freshmen. As well, most departments developed individualized seminars.

School spirit grew exponentially in the 1960s as the number of student organizations increased in the face of a larger student body. Religious groups, social-awareness organizations, fraternities, sororities, disciplinary clubs, athletic-interest associations, and academic societies provided numerous outlets for student enthusiasm. A 1960 pep rally, captured in a photograph from the second floor of the administration building, embodies the excitement of that era.

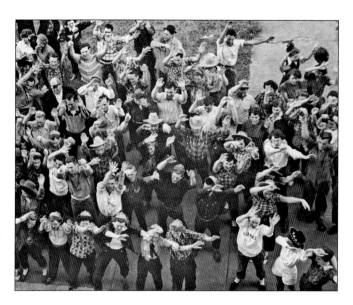

The homecoming queen is being crowned during halftime of an early 1960s football game. Begun in the 1920s, the court is still popular with students today. In the late 1970s and early 1980s, however, enthusiasm for the tradition waned and the students once elected a milk cow from a local dairy as queen. College officials understandably cancelled that particular ceremony and, after a few years, the event resumed as before.

Before photocopying, faxing, word processing, the Internet, and e-mail, the college linotyped and printed a tremendous number of items including catalogs, recruiting materials, course packets, forms, and student newspapers. All academic offices had stencil machines and mimeographs. Instructional media was limited to 16-millimeter films. Until 1980, the college used a hardwire PBX telephone switchboard and also maintained a Western Union Teletype station for rapid communication on campus.

A. J. Carlson came to the college in 1962, after earning a doctorate of philosophy from Princeton University. He served in important positions including dean of humanities and acting academic dean, always teaching classes simultaneously, no matter how time-consuming his administrative duties. A specialist in British history, he also became a champion of the Heritage of Western Culture courses, to which he had a strong intellectual attachment.

Dean Hall marked an important expansion for the college in 1965. At that time, it became the largest building on campus and doubled the amount of dormitory space. This photograph shows the placement of Dean Hall in front of the YMCA building, then the home of the theater department. Theater students bragged that the YMCA had a friendly ghost, named Mortimer, who later followed them to the Ida Green Center.

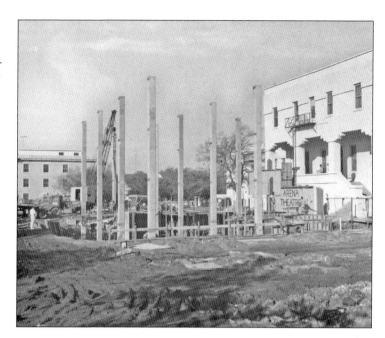

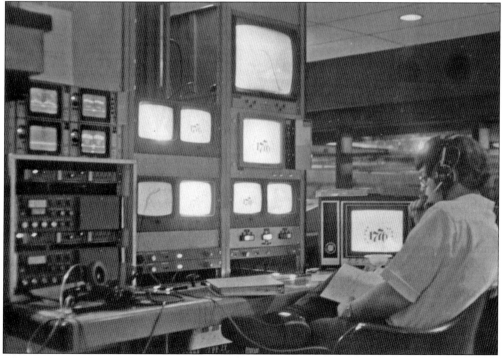

Completion of the Ida Green Center in 1972 brought modern technology to the campus in the form of a fully operational television studio that included two-way instructional contact with classes at other colleges and universities. The theater department enjoyed a spacious arena theater in the basement and a state-of-the art auditorium on the main floor that was dedicated that year by actress Ginger Rogers, who was a college trustee.

Danny Travis Bedsole earned a bachelor of arts degree from Anderson College and a doctorate of philosphy in library science from the University of Michigan. Dr. Bedsole initially served as director of the Austin College library and was responsible for modernizing its operations while adroitly managing its budget. In the fall of 1967, he replaced Leo Nussbaum as academic dean of Austin College. He remained in this position until the early 1980s.

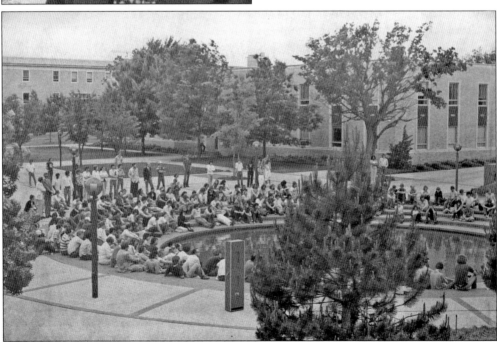

The Margaret Jonsson Fountain was constructed in 1972. Its design permits as many as 500 students to gather around it at any given time. This allowed the fountain to function as a place for speakers and musicians who use a removable island as a small stage. It remains a popular place for students to rest, read, and enjoy their campus surroundings.

Folksinger Joan Baez appears before an appreciative Austin College audience. In the 1960s and 1970s, campus entertainments and special events became more sophisticated. The college drew nationally known speakers, artists, writers, and academics, partially because of the proximity of a rapidly urbanizing area to the south in Dallas and Fort Worth. Under the leadership of its founding director, music professor Cecil Isaac, the Sherman Symphony attracted major classical musicians to the campus, performing for many years at Wynne Chapel before it was moved to the Sherman Municipal Auditorium. Under the leadership of Bruce Lunkley, the campus community series grew from the 1960s to become an important civic tradition that presented Broadway stars, road show engagements, popular musicians, and other featured performers to the campus and Sherman community each year. The student-operated Campus Activities Board began participating in these activities as well, attracting rock groups, dance troupes, singers, and other entertainers that appealed to undergraduate interests to campus.

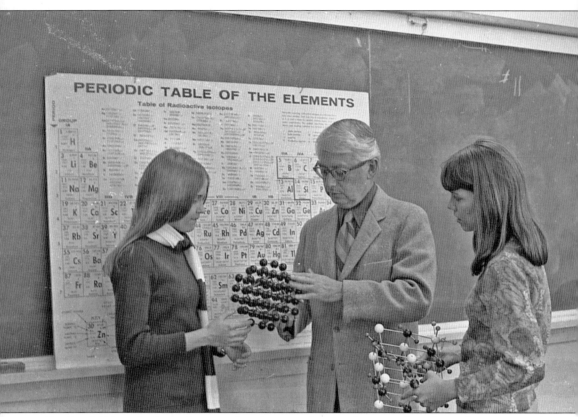

Dr. Frank Edwards (center) was a chemistry professor who served as chair of sciences and as dean of educational research and development. One of his major contributions to Austin College was working tirelessly to help establish the modern science education program during the 1960s and 1970s. Under his leadership, the college identified a faculty member from the biology department to serve as the premedical advisor, a position that still works closely with those students interested in health science careers. Dr. Edwards also directed the comprehensive curricular revision of the early 1970s that resulted in the IDEAS program. It was largely under his leadership that many of the college's innovative programs were designed and implemented. The college's enduring premedical program rests squarely on his efforts. Dr. Edwards was never too busy to meet with students or to mentor them.

Five

A National Liberal Arts College

1979 to 2009

The respective presidencies of Harry E. Smith and Oscar C. Page, which spanned the years from 1978 to 2009, elevated the college to national ranking as a selective liberal arts institution with an established reputation for academic excellence. The recruitment of faculty members from major graduate schools further enhanced the intellectual atmosphere of the school while continued expansion of the campus added significant new buildings. A determined focus on diversity brought a marked multicultural cast to the student body, which has increasingly attracted students from a wide variety of backgrounds and national origins. An increased emphasis on global awareness and study abroad programs internationalized student perspectives as the new millennium dawned. The retirement of Oscar C. Page and the arrival of Marjorie Hass as president during the summer of 2009 marked the start of a new era in the ongoing history of the college.

Harry E. Smith served as president of Austin College from 1978 to 1994. He graduated from the University of Texas and received a divinity degree from Yale University where he later taught. Smith received a doctorate of philosophy in theology from Drew University, making him the first president of Austin College to hold an earned doctorate in an academic discipline. He also served as the chaplain at the University of North Carolina at Chapel Hill. Smith created a more internationally aware college. He was also concerned with values in education, spending much time examining the college's programs to insure that they reflected sound ethical and philosophical foundations. The curriculum returned to a more traditional one, focusing on the academic disciplines with a restructuring of the breadth requirements and Heritage of Western Culture curriculum. He also supervised construction of several new buildings including Wortham Center and the George and Gladys Abell Library Center, also refurbishing older buildings including Hopkins Center, Sherman Hall, and several residence halls.

As seen in this example of 1979 sidewalk art on campus, Austin College manifested a very individualized and values-conscious atmosphere in the closing decades of the 20th century. Students were encouraged to concentrate on broad-based personal development and examine the value structures that embodied their lives. Personal intellectual interaction between faculty members and students became a hallmark of the academic culture and was very much glorified in the recruiting of new students by the admissions office.

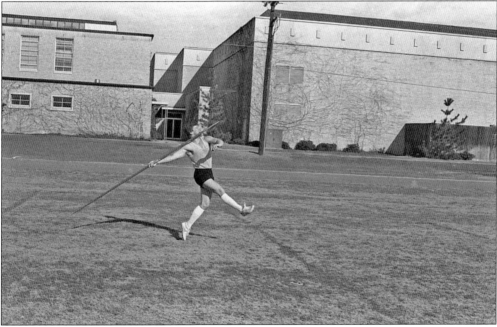

Physical fitness became an important part of the curriculum during Harry Smith's presidency. All entering students received a physical fitness evaluation from the coaching staff that outlined for them an individualized exercise program. All students had to take a general course in physical activity. New lifetime sports classes including golf, swimming, tennis, and aerobics were made part of the curriculum to encourage students to adopt permanent habits of exercise.

Mrs. Gus Wortham, a Sherman native who donated the performing arts center to Houston, also donated the Wortham Center, opened in 1980. The Austin College building was never dedicated because Mrs. Wortham died shortly after it was completed. It houses only administrative offices, as the administration building was cramped and inadequate at the time of its construction. Most students know it as the home of the admissions office.

College Honors Court, pictured here, provided a place to display the name of every graduate. It also has plaques that denote individuals who have served on the board of trustees and who have been significant financial supporters of the college. Added later, the Margaret Binkley Collins Fountain provides a place for reflection and contemplation of Austin College's heritage.

College officials dedicated the Zauk Circle on Grand Avenue as a main entrance to the campus in 1980. It was a gift to the school by Margaret Binkley Collins, a former student and a loyal supporter. The central statue, *Quest*, was sculpted by noted artist Masaru Takiguichi and features intertwining circles moving towards unity. *Quest* has remained popular with students, who jokingly call it the "Roo Doo."

This 1980 aerial photograph highlights momentous changes in the years since that time. Luckett, Cern, and Coffin Halls are now gone, as is the Student Union Building. The Wright Campus Center, the Roo Suites, the Jordan Language House, the Forrester Art Complex, the Dickey Fitness Pavilion, the Jackson Technology Pavilion, the Williams Intramural Fields, and the tennis center do not exist in this photograph, and Jerry Apple Stadium has yet to replace the old football stands.

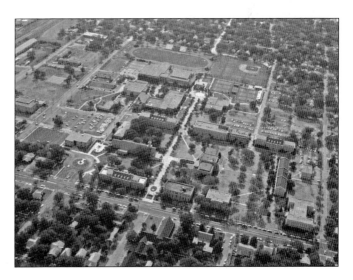

This volleyball match between Austin College and Trinity University women occurred in the late 1980s in the unrestored Hughey Gymnasium when the school belonged to the Texas Intercollegiate Athletic Association and the National Association of Intercollegiate Athletics. Currently all the intercollegiate sports teams participate as part of NCAA Division III and the Southern Collegiate Athletic Conference. The historic Hughey Gymnasium has been completely revamped and modernized.

Members of Kappa Gamma Chi and Phi Zeta Psi participate in the popular pan-Hellenic tug-of-war and the oatmeal throw. The Office of Student Affairs, under the leadership of Dr. Robert Bradshaw until his untimely passing in 1993, encouraged a wide array of student activities and events, as it still does. In the 1980s, Dr. Bradshaw instituted structures for student self-government and created organizations whereby students could plan campus entertainments on their own volition.

The Loggia, located on the back porch of the Student Union Building, became a popular gathering place for those who identified themselves as countercultural individuals. The term "loggia person" as used on campus in the 1980s came to denote a student who was iconoclastic, individualistic, self-directed, and perhaps a bit eccentric, especially if they seemed to be pleased whenever they flouted accepted social conventions.

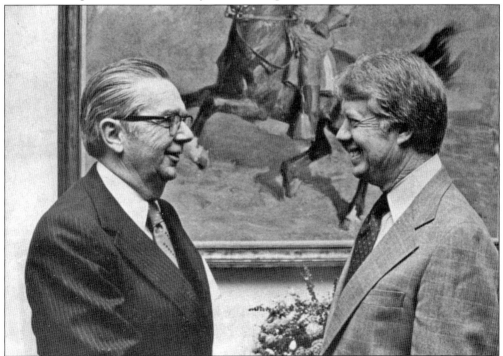

When John D. Moseley left his post as president of Austin College, he assumed the title of chancellor during the early years of Harry Smith's presidency. He also worked closely with the board of trustees and the Center for Program and Institutional Renewal during this time. Tirelessly meeting with community, state, and national leaders, including Jimmy Carter, Moseley helped to continue the advancement of the college.

For many years from the 1950s to the 1990s, the bonfire at homecoming was a great tradition. It occurred at the current location of the Roo Suites. In the 1950s, the "Slime Association" organized the bonfires and gathered materials, ranging from damaged parade floats to park benches. Freshmen acted as sentries over the materials until the fire was lit. The actual lighting ceremony always proved an animated affair.

The Alpha Delta Chi dunking booth at homecoming is a tradition at Austin College, along with the Delta Phi Nu Glob Theatre and the Kappa Gamma Chi Cake Walk. The fall activities carnival sees student groups line the mall with tables to seek new members. Students also sponsor a Halloween carnival. The Great Days of Service occurs when students spend a fall Saturday giving their labor for projects in Sherman.

This is a classroom picture taken in a science lecture hall around 1980, a rare image because the college archives contain very few pictures of classes actually in session. These students are obviously feigning inattention as a joke for the camera. Austin College has a rigorous academic program that emphasizes critical thinking and judgment. Professors allow students to make their own conclusions and facilitate their development as lifelong learners.

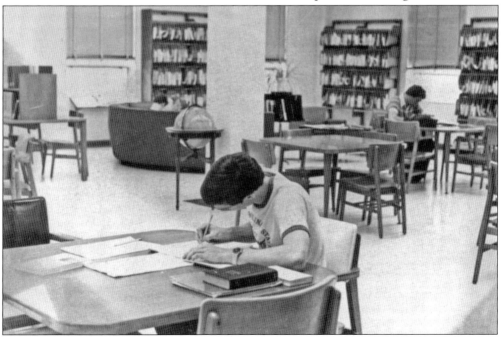

The library has always been a central place for students. This photograph shows the Arthur Hopkins Library about 1985, the final year of its operation. Computers and the Internet have greatly changed the way students do academic research in college libraries. Today many of the reference works and bibliographies that once required a trip to the premises are now online.

During the years of Harry Smith's presidency, students became involved in a variety of social issues and causes. Lectures by prominent speakers on campus opened the college to new ideas. Constantly exposed to controversial and conflicting viewpoints, students were encouraged to form their own opinions. The campus honed successful strategies for students with conflicting viewpoints and ideologies to find common ground. This empathetic viewpoint has become a hallmark of the college.

In the 1980s, football enjoyed a renaissance under the leadership of talented coaches who insisted their players work to be both scholars and athletes. The team amassed a considerable record of academic honors across three decades by fielding over 100 academic all-American players while winning seven Texas Intercollegiate Athletic Association awards during the time it competed in the NAIA. This academic tradition continues today in the Southern Athletic Conference.

In December 1981, the Austin College football team became the NAIA Division II national co-champions along with Concordia College. Concordia was ahead in the last minutes of the game when Kangaroo Gene Branum kicked a record-breaking 57-yard field goal. This tied the game. In the photograph, President Smith accepts the award at ceremonies after the game. Branum later graduated from medical school and pursued a career as a physician.

A group of 1984 January term students led by Light Cummins visit the Roman ruins in Bath, England. The January term is one of Austin College's more distinctive curricular features. Students regularly travel to international locations with faculty members, while many on-campus courses feature experiential learning and innovative educational activities. Some students enroll in various internship and work/study experiences, or engage in supervised independent studies.

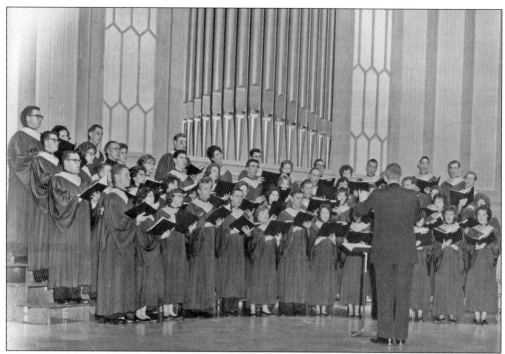

Bruce Lunkley, seen directing the Austin College A Cappella Choir, came to Austin College in 1959 and remained for the rest of his career. Under his leadership, the choir has become a campus tradition. The closing benediction, which ends every performance, has iconic status. The A Capella Choir has its own alumni group and periodically undertakes tours including them.

The Campus Club was founded by Thomas Stone Clyce in 1911, for faculty wives. It still exists, although greatly changed. In the 1980s, as seen in this photograph, it included mostly female spouses whose husbands were faculty members. In that decade, some younger female faculty members rejected the club because it automatically included them as members by reason of their gender. Today it is a service organization for faculty and staff members.

Fountains are landmarks at Austin College and can be seen all around the campus. The Sandra Williams Entrance Plaza, the Jonsson Fountain, the Kappa Foundation, the Margaret Binkley Collins, and others beautify the campus, giving it a park-like appearance. Playing in the fountains, as seen here, is a time-honored student escapade, although college officials usually frown on such activity and do their best to stop it.

The campus group Environmentally Concerned Organization of Students (ECOS) sponsored the first Earth Day on campus in 1970 with students dressed in black to promote awareness. The Center for Environmental Studies works to address the challenges of climate change through research, education, and campus activities. Today, ECOS maintains campus-recycling drops, while the college participates in national efforts to promote sustainability in a wide variety of ways across campus.

The "Car Smash" was a popular event on campus during the 1980s and 1990s. A feature of the homecoming carnival, student sponsors wrote names of frustrating courses, faculty and staff members, and various vexations on the car, then sold tickets to demolish it with sledgehammer blows. When the carnival moved to the College Green, the administration ended the Car Smash in favor of less potentially injurious attractions.

Traditional arena registration for classes, later abandoned in favor of a computer-based system, was a part of Austin College as far back as the early 1980s, as seen in this picture. Though often a stressful time, it provided students with chances to interact and gave them the opportunity to solve problems on the spot. Some students considered it a rite of passage that tied the community together. It occurred in the Sid Richardson Center.

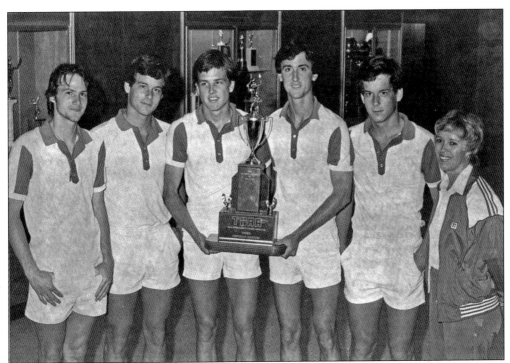

Varsity tennis began at the college in 1935 and had a varied existence until the 1950s when it became a regular intercollegiate sport. The 1985 tennis team, seen here, won the TIAA district championship. From 1972 until 2009, the team played at the Russell Tennis Stadium near the Jonsson Fountain. An exhibition match between actress Ginger Rogers and Frank Edwards marked the facility's dedication.

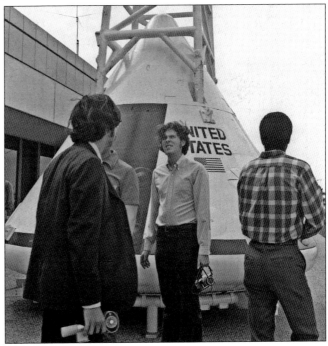

In this photograph from the 1980s, students visit NASA near Houston. The Austin College liberal arts curriculum has only limited coverage of engineering coursework, providing mostly background in mathematics and the physical sciences. Since the 1960s, the school has had "3/2 agreements" with several universities including MIT, Washington University, and Texas A&M, permitting students to cross-enroll and receive an Austin College bachelor of arts degree and an engineering degree in five years.

Oscar C. Page became president of Austin College in 1994 and retired during the summer of 2009. He is pictured here (standing left) with Harry Smith (seated) and John D. Moseley. Dr. Page, a Kentucky native, earned a doctorate of philosophy in history from the University of Kentucky. After teaching at the University of Georgia, he served as a dean at colleges in South Carolina and Georgia before becoming president of Austin Peay University in Tennessee. His years at Austin College witnessed an extensive physical plant expansion, the creation of the Lee Posey Leadership Institute, the founding of several academic centers of excellence, the creation of new faculty positions, and a revision of the curriculum. The latter included the institution of academic minors, new courses in Asian languages, and the removal of Heritage of Western Culture from the graduation requirements. He greatly promoted and expanded the college's commitment to international education, earning for the college the highest national ranking in that category.

118

The 1980s witnessed prominent national educators visiting the college to learn about its programs, which had attracted much attention, including Communication Inquiry for freshmen, the assigning of students to mentors on the faculty, and a formal individual development report that students wrote for their mentors. Second from right, Dr. Clark Kerr, president of the University of California System, chats with faculty members and students during a visit to the campus.

Dr. Page presided over the college's sesquicentennial anniversary in 1999. He went to great lengths highlighting the college's history in Texas and the Southwest. In this photograph, Doris Eagleton Landolt, daughter of Davis F. Eagleton and wife of longtime professor George Landolt, and her son Robert present Dr. Page with the manuscript diary kept by her father on campus during the late 19th and early 20th centuries.

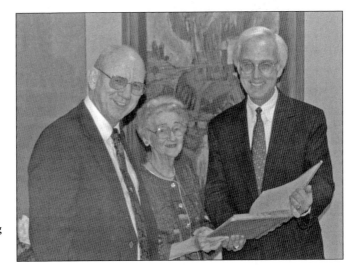

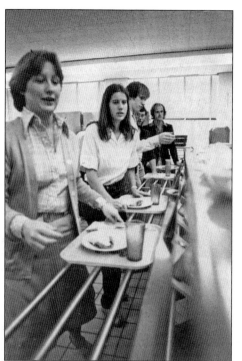

These students are waiting in the cafeteria line in the student union. From the 1920s until 1952, the basement of Luckett Hall contained the dining room, which provided meals family-style. From 1952 until the mid-1980s, the SUB cafeteria line had only limited choices. In the 1980s, a self-service salad bar and several different serving lines began offering an array of choices, which today continues in the Wright Campus Center.

The Kappa Fountain is one of the oldest adornments on the campus, presented in 1924 by the women of the Kappa Gamma Chi sorority to honor the college's 75th anniversary. It stood southwest of Sherman Hall until 1960, when it was moved to its present location at the east end of Windsor Mall. As can be seen in the picture, it is not off-limits, and students are often thrown into it.

Robert J. Wright of Dallas, a dedicated Presbyterian lay-leader and successful businessman, served as chair of the board of trustees. He worked closely with Dr. Page in a variety of significant ways to advance the college in financial development, campus expansion, and increased national prestige. He and his wife, Mary, were the major donors that made possible the construction of the campus center that today bears their name. The Wright Campus Center, designed by Dallas architect Milton Powell, continues the college's traditional architectural norms while it also breaks new, modern ground in providing a focal point for the campus. In addition to the dining facilities, snack bars, student meeting rooms, mail center, and bookstore, the building also houses the staff offices and service personnel directed by the vice president for student life, including the Academic Skills Center. It is also home to the Service Station, the office that coordinates student volunteers for the community, and the Posey Leadership Institute.

Oscar Page has helped elevate the college's national recognition by inviting internationally known leaders including Madeline Albright, the former Presidents Bush, Oscar Arias, and others to campus. He established a special chair in leadership studies. Dr. Page is pictured here with General Colin Powell, who visited as part of this program that recognizes an international leader each year with a significant major award and gala banquet. General Powell spoke to one of the largest groups ever assembled on campus, in addition to meeting personally with classes, faculty members, and students. Since the 1990s, the college has consistently increased its name-recognition in all parts of the United States under Dr. Page's leadership, especially in the areas of globalization and international education. He has done this in a number of innovative ways that are all based on the college's solid academic program.

The Student Development Board (SDB), pictured here on the steps of the administration building, was created in the 1970s to serve the college by giving students the chance to participate in Admission Office activities, assist in fund-raising projects, and be available to the administration for student participation at various formal events. The selection process is rigorous, and students on the SDB take pride in their contributions to the college.

Pictured here is the student election of 1998. The Student Assembly provides students the chance to participate in college affairs and encourages communication throughout all arenas of the institution. There are student committees through which the assembly does its work, including budget and finance, charter review, elections, and public relations. A representative of the Student Assembly attends faculty meetings, while its officers regularly consult with the deans and the college's president.

Dr. Page, who students jokingly called "opage" from his e-mail address, was ubiquitous in the life of the college. In a typical day on campus, he would appear spontaneously at numerous places to chat informally with faculty, staff, and students, most of whom he knew by name. He sometimes went to the cafeteria at lunchtime and walked from table to table talking to students and faculty, not bothering to eat, since interacting with the campus community was what had brought him to the dining room. His wife, Anna Laura, shared his gregariousness, accompanying him to a prodigious number of athletic contests, student functions, faculty socials, formal affairs, informal gatherings, receptions, and other college-related events on a daily and weekly basis. They were the very public face of the college for 15 years on the campus, in the local community, throughout the state of Texas, and across the nation. They excelled at the task.

The academic year begins and ends when robed faculty members and seniors march. Opening convocation, the first Monday of the fall semester, formally begins the year. This convocation starts with the ceremonial ringing of the Sam Houston Bell, a treasured college artifact that today hangs in the campanile of Wynne Chapel. By tradition, it is rung at the start of the ceremony by the student body president. Thereafter, the entering freshman class is formally inducted into the student body. Graduation in May marks the conclusion of the academic year. Students enter the commencement ceremony by marching between two lines of applauding faculty wishing them well. In this picture, the 1980 faculty waits to start its formal march to the opening convocation. Most of the faculty members pictured here, as well as the dog seen at the center of the procession, are gone from the college by death or retirement.

A new era began when Marjorie Hass assumed the presidency on July 1, 2009. Dr. Hass leads Austin College in a world that is, in time and temper, far distant from the day in 1840 that Daniel Baker first arrived in the Republic of Texas. The sectional issues that gripped the college in 1861 are alien to modern sensibilities. The spit and polish of the cadet corps during the 1890s is almost irrelevant. The Great Depression and the Second World War are fading from memory, as those who recall those great events are themselves marching into history. The same will be true of the challenges that occupy Dr. Hass and the college today, because these concerns will also dim and vanish as the years progress. Those who read this book in 75 years will know what we cannot fully realize today; namely, the best chapters of Austin College's history lie in the future. Such has always been the case, and so will it remain.

This volume has been a collaborative effort between faculty members and students. Pictured are the people who worked on this book. From left to right are (first row) Jacqueline Welsh, Victoria Sheppard, Elizabeth Elliott, Rebeka Medellin, Gunjan Chitnis, Ayesha Shafi, Susan Le; (second row) Light Cummins, David Loftice, William Weeks, Trang Ngo, Paige Rutherford, Joshua Pollock, and Justin Banks.

www.arcadiapublishing.com

Discover books about the town where you grew up, the cities where your friends and families live, the town where your parents met, or even that retirement spot you've been dreaming about. Our Web site provides history lovers with exclusive deals, advanced notification about new titles, e-mail alerts of author events, and much more.

MADE IN THE USA

Arcadia Publishing, the leading local history publisher in the United States, is committed to making history accessible and meaningful through publishing books that celebrate and preserve the heritage of America's people and places. Consistent with our mission to preserve history on a local level, this book was printed in South Carolina on American-made paper and manufactured entirely in the United States.

This book carries the accredited Forest Stewardship Council (FSC) label and is printed on 100 percent FSC-certified paper. Products carrying the FSC label are independently certified to assure consumers that they come from forests that are managed to meet the social, economic, and ecological needs of present and future generations.

FSC
Mixed Sources
Product group from well-managed
forests and other controlled sources

Cert no. SW-COC-001530
www.fsc.org
© 1996 Forest Stewardship Council

Find Your Place in History.